The Campus History Series

BERRY COLLEGE

A CENTURY OF MAKING MUSIC

Best Wishes,

ALMA MATER

By M. C. Ewing

Far up in the hills of Georgia stands
Old Berry, tried and true,

The shrine of many a memory of
The Silver and the Blue.

Our loyalty and love we pledge,
God keep thee without fail,

Be thou the light that shines for right,
Alma Mater, Hail, All Hail!

M. C. Ewing

The first alma mater of the Berry schools was entitled "Dear Foster Mother of Our Youth," which appropriately represented Martha Berry's role as an educator and mentor. As the school expanded to become a junior college and then a four-year college in the 1920s and 1930s, Prof. Moses C. Ewing wrote a new school song. Ewing, a member of the music faculty, wrote the current alma mater in 1935 and explained its purpose. "It is to be sung with a spirit of reverence for the schools. . . . [It] should be hymn-like and not a football song." Ewing was instrumental to Berry's music program. He served on the faculty from 1931 to 1955 and is buried in the Berry College Chapel Cemetery along with his wife, Bertha Hackett Ewing, a high school graduate (1917). (Courtesy of the Berry College Archives.)

ON THE COVER: In 1909–1910, the school's band was established "in accordance with the desire of the founder [Martha Berry] to build up at Berry a Music Department, which shall be the largest and best of its kind . . . in the South." Subsequently, the band program was formally organized, and Berry College continues to make music that inspires the mind and stirs the spirit. C. Bernard Keim, standing above clad in white with his beloved trombone, first directed the band. (Courtesy of the Berry College Archives.)

The Campus History Series

BERRY COLLEGE

A CENTURY OF MAKING MUSIC

MARY ELLEN PETHEL
FOREWORD BY STAN PETHEL

ARCADIA
PUBLISHING

Published by Arcadia Publishing
Charleston SC, Chicago IL, Portsmouth NH, San Francisco CA

Printed in the United States of America

Library of Congress Catalog Card Number: 2009938746

For all general information contact Arcadia Publishing at:
Telephone 843-853-2070
Fax 843-853-0044
E-mail sales@arcadiapublishing.com
For customer service and orders:
Toll-Free 1-888-313-2665

Visit us on the Internet at www.arcadiapublishing.com

The music program at Berry has produced memorable melodies and harmonies for over 100 years, but instruments and songs alone do not make music. The success of music at Berry can be attributed only to those who sing and play it. For that reason, this book is but a small token to students and faculty who have shared their passion for music making from generation to generation.

CONTENTS

ACKNOWLEDGMENTS

This book has provided the opportunity to better understand the history and meaning of Berry College music. Throughout my childhood, Berry music was an all-encompassing part of my life. I remember trips to the Hoge Building and Ford Auditorium, concerts in the chapel, music tours throughout the region, and countless Mountain Day picnics. At the age of 12, my first paying job was cleaning instruments and working on a new music inventory for the department. I worked all summer, earning $2.50 an hour. Although I did not become a musician, I have developed my talents as a historian. And so I am thankful that I can give back to Berry's music what it has given to me. Without the help of many, this project would have remained buried in the archives and memories of others. Dr. Ouida Word Dickey brought the content to life through documentation of music at Berry in catalogs, annuals, and other periodicals. Dr. Dickey has long been a vital part of Berry College and its history, and her contributions to this pictorial history only elevate the level of her legacy. I count myself as one of her admirers. Michael O'Malley and Niki Kleto provided the muscle behind the might, pulling and scanning hundreds of images. The Berry archives are lucky to have them. Other individuals provided more specific information to help tell the story of music at Berry, including Dr. Darwin White, Harry Musselwhite, Kathryn Nobles, and Luci Hill Bell. The chairman of fine arts—my father, Dr. Stan Pethel—also deserves a great deal of gratitude. This book began as his vision, and he has contributed from start to finish. Finally Katie Shayda at Arcadia Publishing has provided me with guidance throughout this process. It is my hope that the history of music at Berry College will inspire current and future students and provoke feelings of admiration and reverence for those who came before them. All images appear courtesy of the Berry College Archives.

FOREWORD

The idea for this book came to me when one of our music faculty members asked me for a brief history of the band program at Berry College for a grant proposal he was writing. Having been on the faculty here since 1973, I could cover the last 37 years, but prior to that my knowledge was rather sketchy. I called on Ouida Dickey to help me with the earlier days at Berry's music program. The wealth of information she brought me was wonderfully rich with photographs and stories. I then realized that the music program at Berry had begun formally about 100 years earlier. It seemed only natural to do a book based on music at Berry College and to make 2009 our centennial year.

Music has been a part of the Berry experience since its founding in 1902. In the early days, it was primarily a recreational activity, but as time passed, instructors were hired and music making became a more formal venture. Concert groups were organized and performed on campus, throughout the region, and later in tours overseas.

Berry had its first official music major graduate, Bobby Sims, in 1969. With the graduating class of 2010, there are now over 500 total music graduates from Berry. In addition to music majors, there are hundreds of other students who have participated in musical ensembles and added their voices to the Berry musical tapestry. There is something special about musical participation. It links people together in a unique way. Each year's class connects with those that have gone before and with those yet to come. It has been my privilege to be a part of this process as music at Berry College continues to progress, joining the past, present, and future.

—Dr. Stan Pethel
Chairman of Fine Arts

INTRODUCTION

Berry music was born even before the advent of the Berry schools. In the late 1890s, Martha Berry discovered an old church, called Possum Trot, at the foot of Lavender Mountain. She carried a reed organ with a foot-operated vacuum to the church on the back of her buggy. The organ, called a melodeon, garnered a great deal of interest throughout rural northwest Georgia. People of all ages came down from the foothills of the Appalachian Mountains to hear music and receive lessons. It was the music that first drew young people to Berry's brand of education. By 1900, Martha and her sister Frances Berry began teaching day classes at the church. With community help, the church was repaired and church services were held on Sundays and academic classes during the week. As some argue, "[If] the original cabin is the birthplace of Berry College, then Possum Trot Church is its cradle."

The Berry Boys' Industrial School opened in 1902, and Martha Berry donated 83 acres of her family's estate to construct new buildings. Ultimately, she would donate her family's entire estate of over 6,000 acres, making Berry College one of the largest campuses in the world. She designed the school for boarding only so that her students would not miss class for farming duties at home. The students worked on campus in return for food, clothing, housing, and of course, classes. Students were asked to pay $25 in tuition, but students were rarely turned away for their inability to pay. Some students bartered farm animals, and others worked through the summer to pay for expenses. Berry's first teaching hire was Elizabeth Brewer, a Stanford University graduate who added a wealth of scholarship and experience to campus. By 1906, the school was a reputable institution of academic and technical education but remained in financial jeopardy. Despite rising costs and budget constraints, Martha Berry did not detract from the curriculum, but rather added to it. She created a music department, despite the lack of instruments or a music teacher. Berry hired the first of many well-qualified music instructors, Sophie R. Brooks, in 1906. In 1909, the first band was organized, and Martha Berry required music classes for all of her male students.

Still recovering from the Civil War and Reconstruction, the South lagged in economic development behind northern industrial centers. By the late 1890s, cities such as Atlanta, Nashville, and Birmingham entered a new period of economic growth; however, Martha Berry needed greater financial aid and sought support beyond the Deep South. A daughter of the Southern planter class, Berry realized that for her school to succeed, she would have to coalesce pride with humility. Former president Gloria Shatto remarked:

In that environment the emergence of Martha Berry was the beginning of a miracle in the mountains that is the heritage of Berry College. In an era when women seldom were visible in leadership roles, this aristocratic, genteel young woman was deeply moved by the plight of bright young people from the hills who had no educational opportunity. As she struggled to change their condition she developed a lifelong conviction that while the cost of education was high, the price of ignorance was unacceptable.

By 1925, Martha Berry had met with businessmen and politicians across the country and secured pledges of support from Henry Ford, R. Fulton Cutting, the Rockefeller family, Emily Vanderbilt Hammond, J. C. Penney, Asa Candler Jr. and Robert W. Woodruff (of Coca Cola Company), Erwin Hart, and the Roosevelt family. Andrew Carnegie took a particular interest in Martha Berry and her school. In 1907, he first pledged $50,000 with the promise that his gift would be matched. Berry raised the $50,000, and a new relationship with the philanthropist was born. Carnegie later pledged substantial funding that established the endowment for Berry.

Andrew Carnegie and former president Theodore Roosevelt both urged Berry to open a corresponding school for girls. In a letter from Carnegie to Martha Berry, Carnegie writes, "The boys should not have it alone and for the Girls' School foundation I will give you Fifty thousand Dollars. . . . I know of no better use to make of money." Berry visited Theodore Roosevelt in Washington, D.C., during his presidency. Roosevelt promised to visit her school, but he also advocated a girls' school to provide academic education and practical training for females. Martha Berry responded to the urgings of both Roosevelt and Carnegie, and the Berry School for Girls opened in 1909. Several months later, Roosevelt fulfilled his promise to visit, making a speech to the entire student body and touring campus on the back of a wagon. Today Roosevelt Cabin, named upon his visit, still stands on campus next to the Hoge Building, the school's first recitation hall. The girls' school added much to the music program, as females joined the orchestra and formed several vocal ensembles, including a glee club, the "Ballad Girls," and the Cecilians. In 1917, the school's name changed to the Berry Schools, which included the boys' high school, girls' high school, and foundation (primary) school.

From 1926 to 1957, Berry Schools expanded and refined its curriculum. In 1926, a junior college division was established, and in 1932, after collegiate accreditation in 1930, Berry awarded its first bachelor degrees. Students could minor in general music or major in public school music, and all students were required to take two years of music coursework. Nearly half of the student body also participated in one or more musical ensembles. By the time of Martha Berry's death in 1942, the school maintained a high school division but Berry College had emerged as the main enterprise of the Berry Schools. Music increasingly played a major role in Berry's developing identity. As the 1957 *Cabin Log* observed:

> Music leaps from every stone and twig of the Berry campus. The changing seasons, the cattle grazing quietly in the pastures, and the swans floating gently over the lake's surface sing unending songs. Surround by this it is only natural that music should infuse itself into the lives of the students. All students are given the opportunity to contribute to the music field at Berry. Music helps to brighten the students' day of work and study. . . . Whether sung, played, or heard, music adds a [great deal] to the lives of students here at Berry.

In 1957, Berry College welcomed its fifth president, Dr. John R. Bertrand, and also received accreditation with the Southern Association of Colleges and Schools (SACS). The music department was a key component of Berry's accreditation, and the choral program thrived. Under the direction of Ross Magoulas, the concert choir and newly formed Berry Singers

toured the nation, performing several times on television and singing in towns and cities throughout the eastern United States. In 1968, Dr. Darwin White sought membership in the National Association of Schools of Music (NASM). Acceptance to NASM in 1969 permitted Berry to grant bachelor's degrees in music.

The past 40 years have brought continued recognition and success for the music program. The band and orchestra combined, and today the group is called the Berry College Wind Ensemble. This group has consistently maintained a musicianship of 60 students since the 1970s. The vocal program continues to flourish with both domestic and international tours annually. Berry's piano program also remains prominent, and several brass and woodwind ensembles regularly perform on campus and in the local community. Many music graduates have departed Berry only to revisit as professional musicians. Martha Berry would surely be impressed but not surprised. In the 1930s, construction of the main chapel revealed a hill that obscured the view of the new building. Berry "ordered the hill removed, [and t]he students did it in a matter of weeks," according to the *Southern Highlander*. These students literally moved a mountain in order to support the school's mission, "Not be ministered unto, but to minister." Berry music has done much to minister and remains a worthy ambassador of Berry College. For 100 years, Berry's music has permeated campus and resonated throughout public forums both near and far. Today Berry College boasts over 1,800 students and has regularly been named in the top 100 liberal arts colleges by *U.S. News and World Report*. Music will continue to play a large role in campus life and culture as "Hearts soar and courage is renewed by the language of the soul—music (*Cabin Log*, 1954)."

One

OVERTURE
1906–1929

Evelyn Hoge Pendley, associate professor emeritus of English and a 1938 graduate, wrote an epic poem entitled *The Vision Victorious*, recounting the early days of the Berry Schools. Published by Ouida Dickey and Doyle Mathis in *Martha Berry: Sketches of her Schools and College*, Pendley's composition reveals a nostalgic view of the 1907 commencement ceremony:

> Long hours of labor. Yet her spirit thrilled,
> Feeling her vision partially fulfilled,
> To know at last her school was sending out
> Trained hands into the world, hearts that were stout . . .
> All that they did should make her proud.
> Inspired with hope, she walked on a cloud . . .
> For all available that might impress,
> The speaker, families, and other guests.
> They had but one big bass drum by which they marched
> Donned in their best apparel—collars starched,
> Shoes shining, and their coats and pants well pressed.
> Patched and ill-fitted, still they looked their best.

From 1906 to 1920, the Berry music program developed steadily but certainly endured growing pains. Sophie R. Brooks, Edith L. Freeland, E. Floyd Johnson, W. Arthur Sewell, Gordon Keown, Georgia L. Hoag, Mrs. J. C. Bell, and Emma Johnson all taught music at Berry, but none remained on the faculty more than three years. Martha Berry recruited each of these instructors from elite music schools across the country. Despite the instability caused by faculty turnover, each left a positive mark on the music program. They taught music classes to all students, recruited members for the band, orchestra, and various vocal groups, and helped expand the repertoire and reputation of Berry music throughout the community.

By the 1920s, music was firmly entrenched as a staple of campus culture, and Martha Berry regularly used musical groups to entertain guests and possible donors. Two faculty members ultimately made the school their professional home. C. Bernard Keim and Alice B. Warden took a fledgling program and gave it musical wings. Each serving over 30 years, these two individuals helped to shape the music department and set standards of excellence for decades to come.

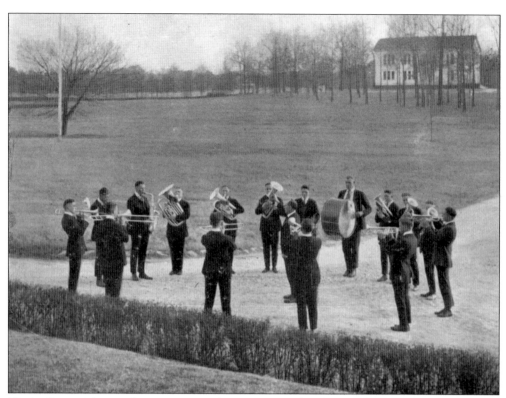

The earliest evidence of a Berry music department surfaced in 1906, four years after Martha Berry officially began the Berry School as a boys' industrial school. In that same year, she hired the first music teacher, Sophie R. Brooks of Springfield, Massachusetts, who arrived in Georgia to provide both instrumental and vocal instruction. Brooks had several years of experience at Mount Hermon School. No regular classes would be introduced that term, but short periods for drill were taken during the chapel hour weekly. Private instruction was also to be given to the boys, and later girls, in organ, piano, and voice. By the end of Brooks's tenure in 1909, the school's music department had become an indelible part of school culture.

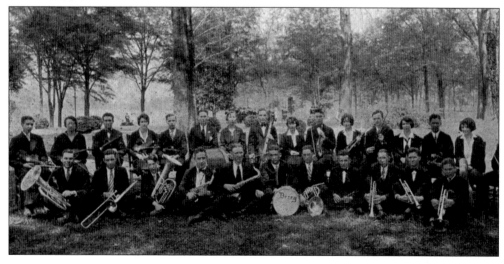

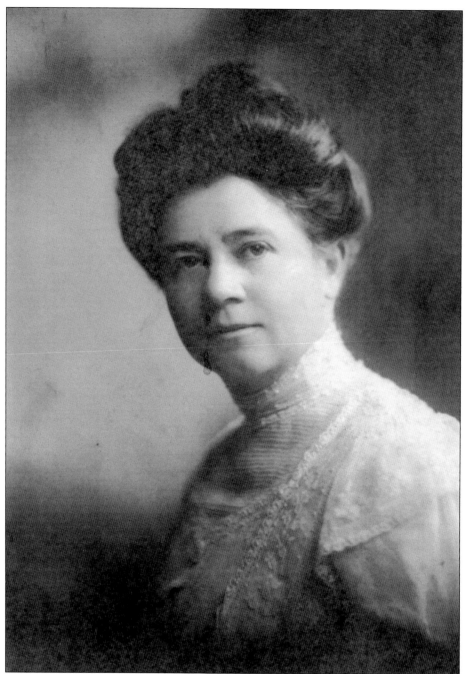

As the 1906 *Southern Highlander* noted, "A long cherished plan of Miss Berry's has been realized in providing instruction in music, both instrumental and vocal." Founder Martha Berry tirelessly raised funds in order to provide members with instruments and uniforms. In 1909, the first band was comprised of 24 members and many times served as a marching band, leading the student body in parades, rallies, and other celebrations. By the 1912–1913 school year, the four courses of study listed were agricultural, academic, college prep, and music. The portrait above reveals a younger Martha Berry at the beginning of the 20th century.

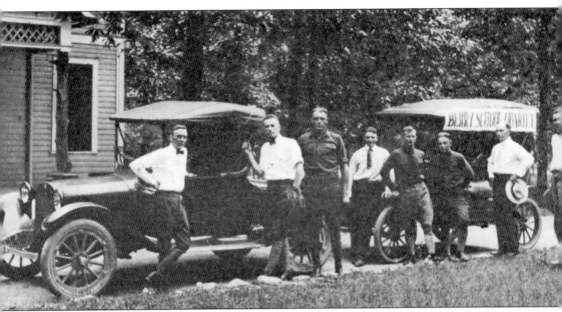

Berry maintained a special relationship with Henry Ford, founder of Ford Motor Company. In fact, Martha Berry's personal telephone book reveals Henry Ford's direct phone number penciled on the cover. With the financial support of Henry and his wife, Clara, the remarkable Ford Buildings complex was constructed. The first building, Clara Hall, was completed in 1925 and used as a girls' dormitory. Construction continued through the early 1930s. Ultimately, the Ford Buildings expanded to include nearly 10 structures. The Ford Buildings remain one of the school's most outstanding landmarks, and one of its buildings currently houses the music department. Above, the Berry Quartet poses with one of Ford's Model T cars and their director, Gordon Keown (right). Keown was also one of Berry's first graduates and subsequently served on the faculty and on the newly formed music committee from 1919 to 1920.

Daily chapel was required at Berry. Although the school was not tied to any religious denomination, Martha Berry was a devoted churchgoer and felt that the influence of Christian principles and morals was essential to creating strong ethical character. The Protestant Episcopal Church Hymnal of 1916 was often used in chapel services.

THE HYMNAL

AS AUTHORIZED AND APPROVED FOR USE BY THE GENERAL CONVENTION OF

The Protestant Episcopal Church in the United States of America

IN THE YEAR OF OUR LORD MCMXVI

THE CHURCH PENSION FUND
NEW YORK

School Song

(Air "Fair Harvard")

*There's a glory that hovers o'er Dixie's fair
 hills,
And a sweetness that dwells in each vale,
There's a music that rises from myriad rills
In a chorus that never shall fail,
'Tis the South we adore, in the land that we
 love,
'Tis the fairest and noblest on earth;
In the strife of the years faithful sons we will
 prove,
To this mother that gave us our birth.*

*There's a school that we now set amidst
 Dixie's Hills,
Kissed by breezes both fragrant and cool;
And the heart of each loyal son joyously
 thrills
With love for the Berry School.
There's a charm in our fellowship noble and
 free;
For we feel that each comrade is true
And we'll ever press forward to sure victory,
'Neath our banner, the Silver and Blue.*
　　　　　　　　　　　　—R. H. Adams.

The Berry School song was written in 1909–1910 by the school principal, R. H. Adams. The lyrics reflect the strong emotions of rural regionalism and Southern identity. Adams served as principal from 1908 to 1914 and was one of Martha Berry's earliest hired faculty members. He previously taught at the Mount Hermon School in Massachusetts and came to Berry Boys Industrial School in 1904.

The Berry School catalog of 1908-1909 announced "A two-year course in Music in class is required" and listed Edith L. Freeland and E. Floyd Johnson as music instructors. In addition to the two-year study requirement, "a singing drill is given the whole school twice a week." By 1910, the school maintained a quartet and glee club and offered private lessons. However, all students were required to complete the two-year course of study in music in addition to their other studies. Pictured here are two of the texts used by Berry students. The first is taken from *Presser's First Music Writing Book*, published in 1910 by Theodore Presser Company of Philadelphia. The second text was used for piano and published by the Arthur P. Schmidt Publishing Company in 1905.

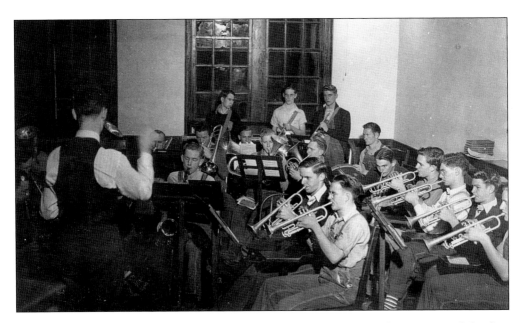

After initiating the band program at Berry in 1909–1910, C. Bernard Keim started the first Berry orchestra in 1918. As the *Berry Alumni Quarterly* reported, "For the first time in the history of Berry School we have organized a student orchestra which is doing very acceptable work." Keim came to Berry as a graduate of Wooster Conservatory of Music in Ohio. Serving 33 years, from 1911 to 1944, C. Bernard Keim remains one of the longest tenured music faculty members. In the first picture, Keim directs the newly formed orchestra, while the bottom photograph gives a rare glimpse of him teaching a boys violin class.

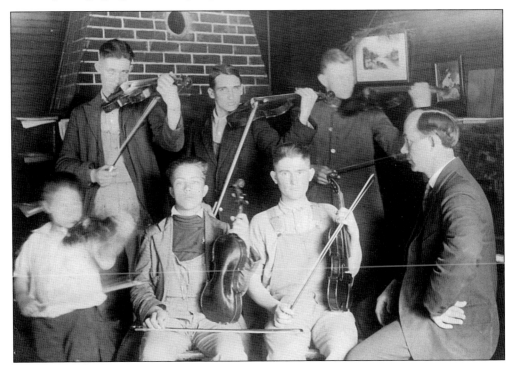

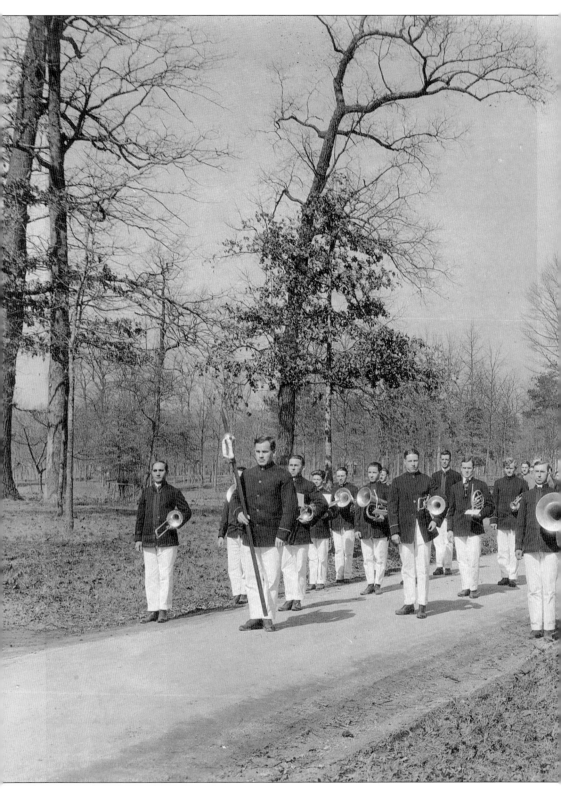

Berry College has long featured its musical groups in special events and for honored guests. By 1907, Martha Berry was "bringing out the brass band" (including some hired musicians) to welcome the Honorable Hoke Smith, former governor of Georgia. Here the band leads the student body in front of Blackstone Dining Hall in 1918 with Berry (right) standing guard. Blackstone Dining Hall was the first brick building constructed on campus and was completed in 1915. The building served as the men's dining hall (1915–1978) as well as the library (1915–1926). Since 1982, Blackstone Hall has housed the school's theater department. Blackstone Hall is one of Berry's buildings listed on the National Register of Historic Places.

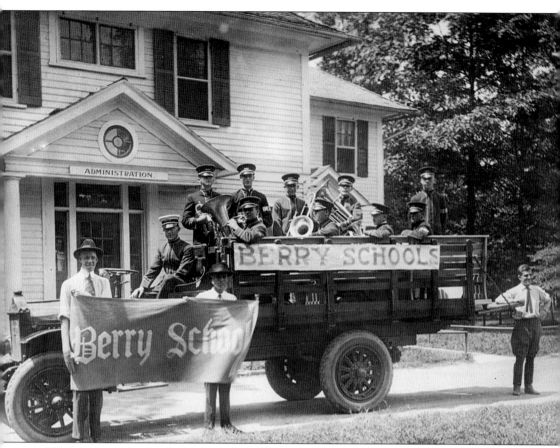

The Berry Band is loaded and ready to make its way to Festival Day in 1918. The band is in front of Boxwood Cottage, an early administration building. Boxwood Cottage still stands and is presently used for faculty housing. Festival Day included programs by the band and orchestra, a glee club concert, and singing of folk songs. The *Southern Highlander* described the day as a "rousing program of community singing in which everyone will be privileged to have a part. This program will be given in 'God's great out of doors.' " The main festival that developed into an annual event doubled as a birthday celebration for Martha Berry, born on October 7, 1866. Today the first Saturday of each October, known as Mountain Day, continues to commemorate its founder with a homecoming picnic, grand march by current students, and athletic events. The music performed by the band throughout the Saturday festivities remains a highlight of the event.

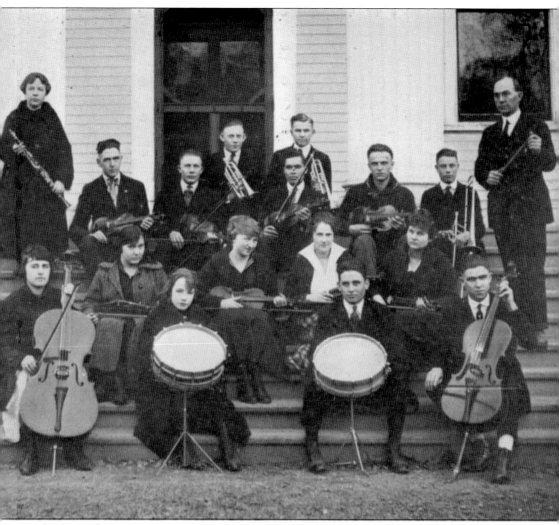

Martha Berry's love of music and desire to develop the musical appeal of chapel services inspired her decision to make music a permeating part of campus life. By the early 1910s, the curriculum expanded to class offerings in piano, voice culture, sight singing, ear training, elementary theory, history of music, conducting, melody writing, and harmony. One description from the mid-1910s reflects the growing importance of music in education. "Recognizing the value of Music as a factor in education, and seeing the great need for community leadership . . . the Berry School is now offering a [two-year] course in Music . . . that serves as an excellent preparatory course for the student who wishes seriously to take up the study of Music." In the above picture, director C. Bernard Keim (right) stands with the orchestra in 1921.

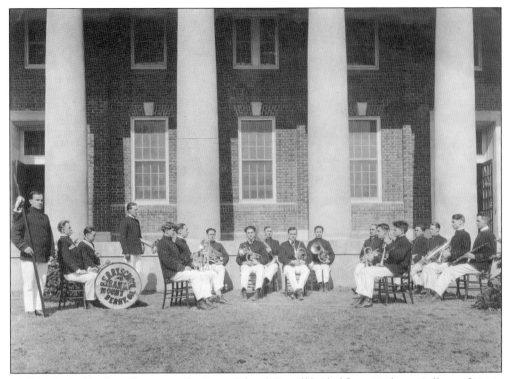

In 1915, W. Arthur Sewell came to the Berry School. Sewell hailed from Bethany College of Music and Fine Arts in West Virginia. He quickly became the chairman of the newly formed Music Committee and remained in that position until his departure in 1917. In the first published *Catalogue of the Berry School* of 1915–1916, the band was duly noted. "A Berry School band of sixteen pieces plays daily in the dining room and frequently at athletic meets and public gatherings. . . . The members receive daily instruction and credit equal to that for any daily study." The first photograph displays the 1915 band with its director, W. Arthur Sewell (left), in front of Blackstone Hall. The second photograph shows the marching band in 1917.

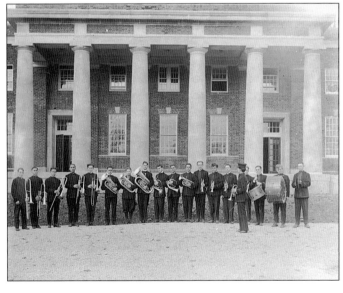

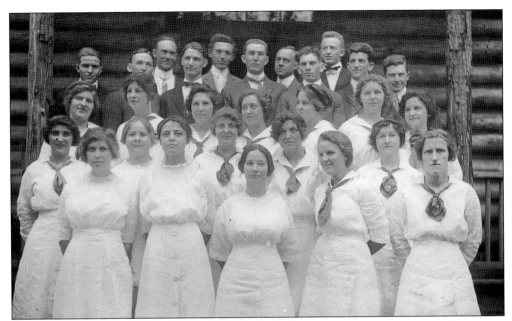

In 1909, a girls' school was added, and these young females had an immediate influence on the music program. Pictured above, the 1914 Berry Choir enjoyed a large female contingency. Although men and women attended classes and dined separately, certain music groups including choir and orchestra were coed. The choir sang at Sunday services and special events.

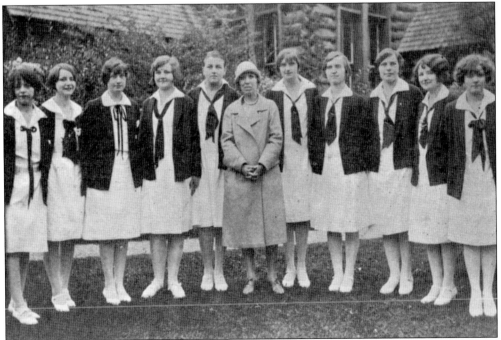

Men and women who participated in glee club practiced and performed separately. The band also continued as male-only until the late 1930s. Special female groups and clubs emerged in the 1930s, such as the Ballad Girls and the Cecilians. Here the girls' glee club poses for a picture with its director, Alice Warden, in the 1920s.

Georgia L. Hoag came to Berry in 1918 as an assistant in the Department of Music. Hoag was a native of New York. She graduated from Syracuse University with a bachelor of music degree, an exceptional achievement for women during the early years of the 20th century. Most women with collegiate training attended women's seminaries or "colleges" and earned the modern equivalent of a certificate or associate degree for their area of study. The school boasted that "Miss Hoag has won many distinctions as a musician, and her musical abilities, together with her pleasant manner have won for her a place in the hearts of all wherever she is known . . . [and] students count it a rare privilege to have her as a class teacher."

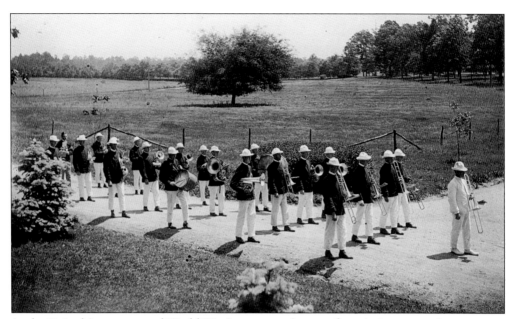

As the United States entered World War I, a renewed wave of patriotism crested on campus. Berry unfurled a new "Service Flag" dedicated to honor the war effort. The band played an integral role in the many patriotic rallies held in 1918 and 1919. Patriotic and school songs were also an important part of these events. In one service, M. Gordon Keown, president of the Alumni Association, read aloud the 350 names of former students and faculty serving in the war as well as the "heroic dead—six boys who ha[d] made the supreme sacrifice." To honor these men, the Service Flag bore 300 blue stars and 6 gold stars. Pictured here are two examples of the Berry Band marching in patriotic parades and rallies.

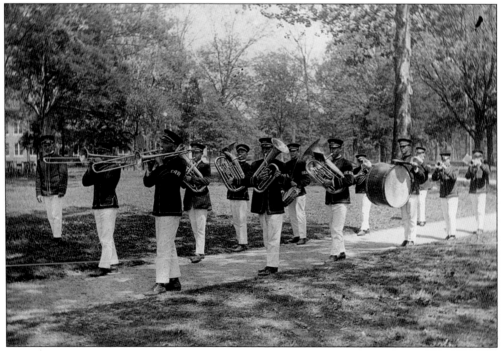

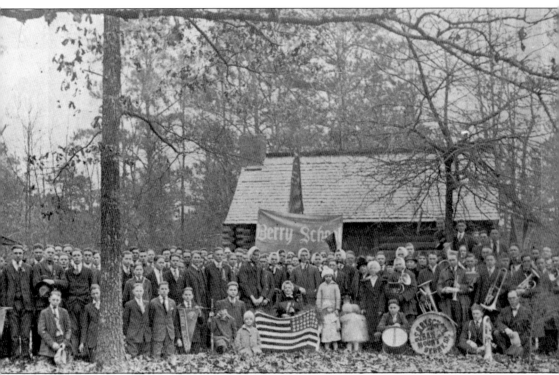

January 13, 1919, marked the 17th anniversary of the Berry School, and it was "most enthusiastically celebrated" with an all-day parade and picnic led by the school band. Led by director W. Arthur Sewell (left), the band poses first in front of Blackstone Hall. The parade marched across campus, where the daylong celebration included students, faculty, alumni, and special guests. As described by the *Southern Highlander*, the band "marched over in the morning to Miss Berry's home, with flags flying and class colors fluttering. . . . In a chair of state, Miss Berry was carried over to the little old log cabin which saw the genesis of the work. The school sang as they marched along." Martha Berry sits proudly in a chair behind the American flag, flanked by students and faculty.

The *Spectrum* served as the first yearbook of the Berry School and includes pictures of the orchestra, the band, and the Berry Quartet. From left to right are the 1921 quartet members John Brooke (first tenor), Louie Herring (second tenor), Broadus Moak (baritone), and Fred Roberts (bass). The school also developed its own cheer to be performed at parades, picnics, and other spirited school gatherings. It is apparent that by the mid-1910s the Berry School had cemented a unique culture that stressed excellence. As the inscription on the Green Building, built in 1921, proudly proclaims, "Whether at work or play, always do your best."

School Yell

Boom—Chick—a—Boom!
Boom—Chick—a—Boom!
Boom—Chick—a—Rick—a—Chick—a
Ricka—Chicka—Boom!
Sis—Boom—Bah!
Sis—Boom—Bah!
Berry! Berry!
Rah! Rah! Rah!

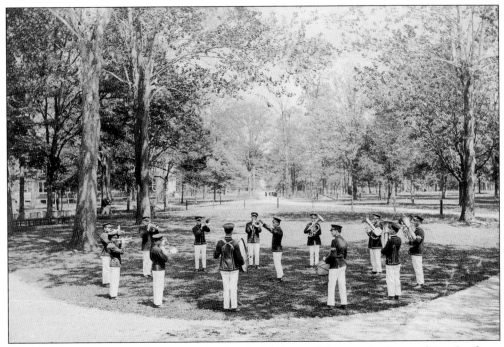

Berry College has always been a rural school with beautiful grounds. Located 3 miles from Rome, Georgia's downtown, Martha Berry initially refused even students from Rome. Her goal was to provide an education through study and work to young people otherwise without educational opportunities. In fact, Berry named the main gate of the school the "Gate of Opportunity." The campus maintains 26,000 acres, one of the world's largest college campuses. Today the campus is divided into a "Main Campus" and a "Mountain Campus;" however, both are surrounded by the scenic beauty of mountains, lakes, and forests.

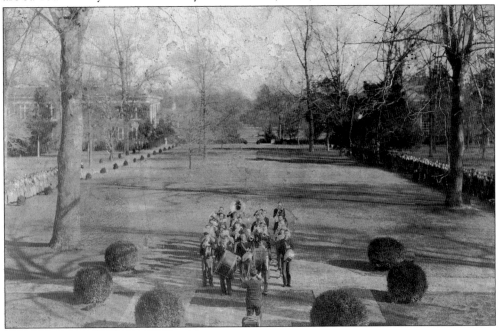

After the short-lived tenures of Mrs. J. C. Bell of the Cincinnati Conservatory of Music and Berry alumna Emma Johnson in 1921–1922, a new face joined the department that would have a lasting influence on music making at the Berry School. Alice Warden completed her musical studies with the Boston Conservatory of Music. Warden became the assistant director of the music program. An accomplished pianist, she taught music, directed the girls' glee club and Cecilians, organized the Ballad Girls, directed the annual Christmas pageant, and served as the organist for chapel services. She was well-traveled and often used her life experiences to enhance her teaching. Warden remained a vibrant part of the Berry faculty for 28 years, until her death in 1950. As the *Southern Highlander* lamented her passing, "She will live in the hearts of Berry boys and girls, whom she taught the beauty, inspiration, and joy of music. And her life of service, devotion and faithfulness will ever be an example for them to follow."

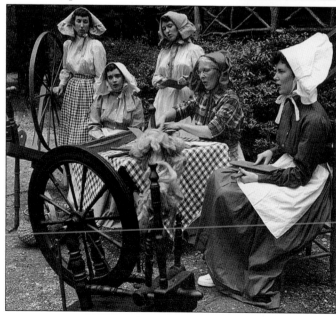

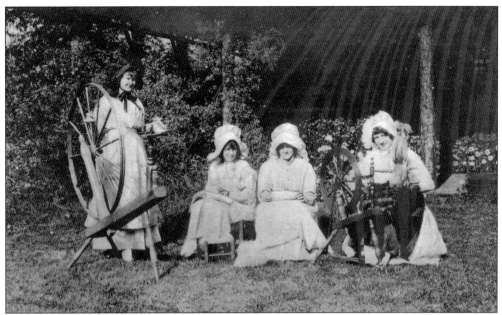

"Down, down by the weeping willow / Where the violets cease to bloom / There lay my sweet fair Rilla / Lay silent in a tomb." This is but one of the melodies resonated by the Ballad Girls. Alice Warden organized the Ballad Girls, a unique group that joined history and music, showcasing local culture and heritage through song and performance. The group formed in the early 1930s and helped to revive old folk songs and ballads of the southern mountains. They dressed in clothes befitting the mid-1800s and were accompanied by a dulcimer. The group spun and reeled flax and wool while singing. Martha Berry viewed them as ambassadors of the school when touring and often asked them to perform for special guests on campus.

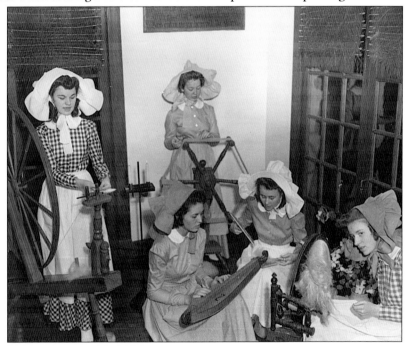

CINDY

Chorus: Git along home, Cindy, Cindy
Git along home, Cindy, Cindy
Git along home, Cindy, Cindy
I'll marry you sometime.

oughta see my Cindy,
lives away down South,
she's so sweet the honey
swarm around her mouth.

sh I was an apple,
nging on a tree,
every time that pretty gal passed
d take a bite of me.

sh I had a needle,
ine as I could sew,
sew that gal to my coat tail
down the road I'd go.

Cindy got religion,
thought her time had come,
walked right up to the preacher
chawed her chewin' gum.

Cindy got religion,
She'd had it once before,
When she heard my old banjo,
She 'uz the first un on the floor.

She took me in her parlor,
She cooled me with her fan,
She swore that Ize the purties' thing
In the shape of martal man.

Cindy hugged and kissed me,
She wrung her hands and cried,
She swore I was the purties' thing
That ever lived or died.

She told me that she loved me,
She called me sugar-plum,
She throwed her arms around me
And I thought my time had come.

The Ballad Girls grew very popular and toured throughout the southeast. The song above was a favorite of the Ballad Girls and was performed often. Upon arriving to teach at Berry, Alice Warden became fascinated with folk ballads that she heard from students and locals. She began writing them down and then traveled "into the mountains to find other ballads that had never been recorded, and which had been handed down for generations by the mountain families (*Southern Highlander*)." Many of these ballads were indigenous to the rural populations of North Carolina, South Carolina, Tennessee, Virginia, and Georgia. However, the origins of these ballads were not from the southeast, but rather variations of 18th- and 19th-century songs from Western Europe. In 1940, several individuals from Great Britain discovered the work of the Berry group and traveled to the school in order to complete collections of songs from the Elizabethan period. Although the words and melody were slightly varied in many cases, each ballad remained recognizable.

The Berry College music program continued to develop in the 1920s, as did the entire school. The Berry Schools grew in numbers of students as well as new buildings. By the late 1920s, the enrollment included approximately 500 students, with more than 90 percent working on campus to meet their tuition costs. Campus also expanded with the construction of the Ford Buildings, Mothers Building (the original wing of the Evans Building), and Memorial Library. Above, C. Bernard Keim warms up the band around 1920.

JOHN PHILIP SOUSA PRAISES BERRY'S BAND

John Philip Sousa, the World's Greatest Bandmaster, visited a nearby city with his band and came over to Mount Berry to see the work which Martha Berry is doing. Mr. Sousa heard the schools' band play and encouraged the boys by expressing his delight with the fine music they rendered. As he left the schools Mr. Sousa said, "This is a wonderful work and needs every encouragement."

John Philip Sousa, known as a great American conductor and composer, was perhaps best known for his march "Stars and Stripes Forever." He conducted the U.S. Marine Band until 1892, when he started his own civilian band. The John Phillip Sousa Band was the most popular of its time and toured across the country in the 19th century and early 20th century. He wrote 136 marches and nine operettas. Needless to say, his 1924 visit to Berry and the compliments given the music program served as validation and encouragement of Martha Berry's emphasis on music.

As graduation for the class of 1923 neared, each student pledged to donate $10 to the school. Over half had already been raised by graduation in May. Traditionally, the students created an honor guard that lined the path of the processional. Leading the way was Martha Berry, attended by the chancellor of education, as the band played for the special event. Three years later, the Berry School experienced a matriculation of its own. In 1926, the school was accredited as a junior college. The high school and foundation (grammar) school also continued in their capacities; however, the Berry Schools would focus most heavily on its collegiate development.

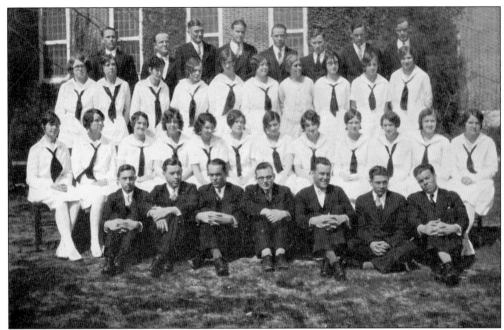

In both the high school and junior college, music played a large role in the curriculum and school culture. The school offered 10 different music classes. By the late 1920s, the choir had grown to over 30 voices strong. Many secondary schools and colleges throughout the United States charged extra fees for students taking music courses. This was not the case at the Berry Schools, where students received "free" musical instruction and were provided with instruments (if necessary) as long as they maintained punctuality and attended all rehearsals and performances. Above, the 1930 choir poses for its annual group photograph. Below, C. Bernard Keim stands with the 1923 Berry men's quartet, which, by 1920, had gained a regional reputation for excellence. The members were, from left to right, C. Bernard Keim, T. D. Wells, Lester Pander, Charlie Metcalf, and Marlin Fitts.

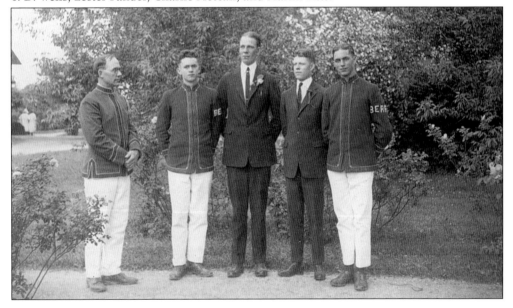

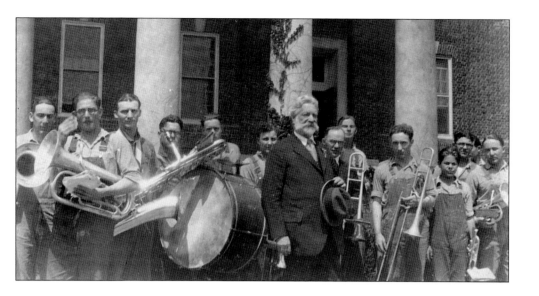

Ovid P. Barbour came to Berry in 1927 and remained until 1930. Barbour came with an impressive resume, having attended Oberlin College and Columbia University. He also taught at the Stuttgart Conservatory of Music before relocating to the rural settings of the Berry Schools. At Berry he taught "violin and orchestral instruments." His wife, Blanche Barbour, was also an accomplished musician who accompanied her husband. She studied at the Royal Conservatory of Music in Dresden. At Berry, she taught voice and chorus classes. Here O. P. Barbour poses with the band after a practice and again before a performance. All of these young men also worked in the fields and school industries in addition to taking classes and playing in the band.

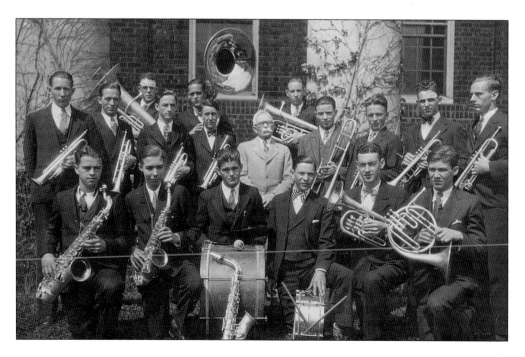

1.	Morning, Noon and Night Overture	Arr. Fillmore
	BAND	
2.	Angel's Serenade	Braga
	T. D. Wells and David Driggers	
3.	Massa Dear, from "New World Symphony"	Dvorak
	MALE QUARTET	
4.	When the Baby Vakes up in the Morn, Yodel Solo	Cawthorn
	David Driggers	
5.	Celestial Aida, from "Aida"	Verdi
	Mr. Wells	
6.	Sorter Miss You	Smith
	LADIES' QUARTET	
7.	Poet and Peasant and Light Cavalry March	Fillmore
	BAND	

8.	Absent	Metcalfe
	MALE QUARTET	
9.	My Heart at Thy Sweet Voice from "Samson and Delilah"	Saint-Saens
	Ouida LaVonne Keim	
10.	The Stars are Brightly Shining	Bronte
	Girls' Glee Club	
11.	Hungary	Koelling
	Lemma Blackwelder	
12.	Promis' Lan'	Burleigh
	MALE QUARTET	
13.	Scenes from Operaland	Arr. by Hayes
	BAND	
14.	(a) O Hail Us, Ye Free	Arr. by Parks
	(b) Perfect Day (an arrangement)	Bond
	(c) Favorite Songs	Selected
	Boys' Glee Club	

Despite a new division between the high school and junior college, every student was required to take two years of music. The Berry Schools also began regularly scheduling concerts to showcase each of its musical groups. At left, the 1924 spring concert, entitled "Musical Night," featured most of the school's organized groups and reflected many genres of music from classical to spirituals.

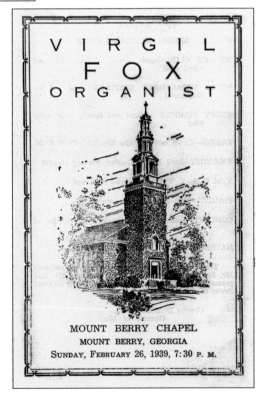

VIRGIL FOX ORGANIST

MOUNT BERRY CHAPEL
MOUNT BERRY, GEORGIA
SUNDAY, FEBRUARY 26, 1939, 7:30 P. M.

In 1928, a new lyceum course was added. This course brought guest speakers and performers from across the United States to the small mountain school. One example of this new series includes the world-famous organist Virgil Fox. The program announces that his concert was the sixth of the year in the newly named "Music Concert Series" of the Berry Schools.

Two

CRESCENDO
1930–1958

As the nation endured the highs and lows of the Great Depression, World War II, and the baby boom, Berry also experienced great change. The Berry Schools' philosophy of self-sufficiency through student labor proved valuable as the South struggled through the economic downturn of the 1930s. New buildings constructed in the 1930s included Richards Memorial Gymnasium, Lemley Hall (dormitory), Trustees Hall (classroom building), and the Moon Building (originally a school store and post office). The Ford Buildings complex was also completed in the 1930s. Although the institution maintained the name Berry Schools, Berry College emerged after collegiate accreditation in 1930. By the end of the decade, Berry College had emerged as the largest part of the institution, but the high school division continued with solid enrollment and well-qualified faculty. With the shift of focus and the growing momentum of Berry College, the music department benefited. C. Bernard Keim chose to lead the high school division, while new faculty members were hired to expand the collegiate music department. The number of musical ensembles also doubled with separate bands, orchestras, and choirs for the high school and college. The Berry Schools now made twice as much music, to the delight of Martha Berry and the local community.

By 1941, ominous reports from Europe and Japan soon led to the entrance of the United States in World War II. As the nation suffered the hardship and pain of war, the Berry Schools also experienced a major loss. Martha Berry passed away in 1942 at the age of 76. Following her death, the schools entered a period of instability. In 1956, the girls' school (high school division) closed. Still, the music program flourished throughout the 1940s and 1950s. Berry students remarked in 1942, "The band is enjoyed by all when it plays for Joint Chapel and in its 'jam sessions' in front of the dining hall before lunch. . . . [T]he enthusiasm of the members combined with the able leadership of Professor Hill, always brings the band through with flying colors."

In 1931, Moses (M. C.) Ewing came to Berry from Durham University and McGill University to assume the duties of music director for the junior college. Alice Warden continued to serve as director of music at the Martha Berry School for Girls, and C. Bernard Keim remained the head of music for the boys' school.

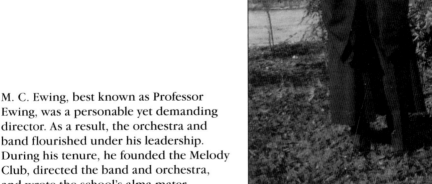

M. C. Ewing, best known as Professor Ewing, was a personable yet demanding director. As a result, the orchestra and band flourished under his leadership. During his tenure, he founded the Melody Club, directed the band and orchestra, and wrote the school's alma mater.

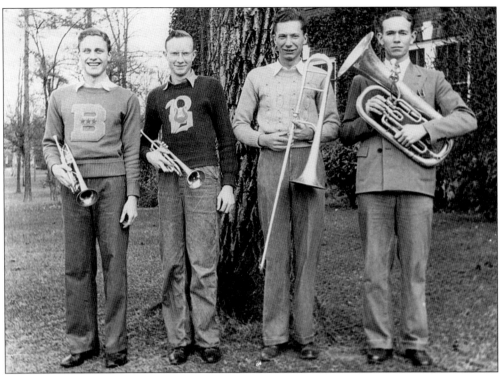

The Melody Club was founded in 1931 and was an organization "that endeavored to promote interest in, and uphold the high standards of music attainment at Berry." In order to become a member, students were required to participate in one or more of the musical groups at Berry. Ewing stated the Melody Club was for men and women "who ha[d] shown marked ability in individual effort and faithful attendance at all practices and rehearsals." Inductees were required to pass a written examination given by Professor Ewing. Once a member of the Melody Club, members received a "B" music letter for their jacket or sweater, but with a musical twist. Above, the first photograph shows a brass quartet with the member (second from left) wearing the "B" music letter, while the second image exhibits the Melody Club (with Ewing at center) in 1935.

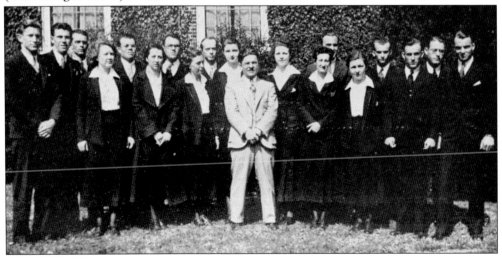

BERRY SCHOOLS
SONG BOOK

MOUNT BERRY, GEORGIA

In the early 1930s, the Berry Schools compiled a songbook (at left). The collection of songs included lyrics to the alma mater, the school song, and others written by students or faculty about the Berry Schools. Also included are songs that reflect both Southern regionalism as well as nationalism. Students who attended Berry were fiercely loyal, as selected lines from the "Berry Loyalty Song" reveal: "Amid the rolling hills that nourish our land / For honest labor and for learning we stand / And unto thee we pledge our heart and hand / Dear Alma Mater, Berry School / We're loyal to you, Old Berry; We never get blue, Old Berry / We'll back you to stand / For we know you have sand, Old Berry / Rah! Rah!" Two additional examples of Berry-inspired songs are seen below.

O! BERRY SCHOOL

O! Berry School, dear Berry School,
The years may come, the years may go,
Yet shall our hearts in memory hold
These happy hours that quickly flow.

CHORUS: O! Berry School, dear Berry School,
Ever to thee may we prove true.
To Berry School, our Berry School,
Faithful where'er we go.

Through youth, through prime, and
When the days of harvest time to us draw near,
Through all we'll bear in memory
Old Berry School and comrades dear.

THE BELLS OF OLD BERRY

(Tune: THE BELLS OF ST. MARY)
The bells of old Berry
At sweet evening tide,
Shall call back to memory
The School of your pride.
While out in the valley,
Or on the hillside,
Here waits you a welcome
Whatever betide.

Chorus:
The bells of old Berry
I hear they are calling
The old friends, the new friends
Who come from afar.
And so my beloved,
When red leaves are falling
The bells of Berry will ring out
For you and me.

Repeat chorus:

- 6 -

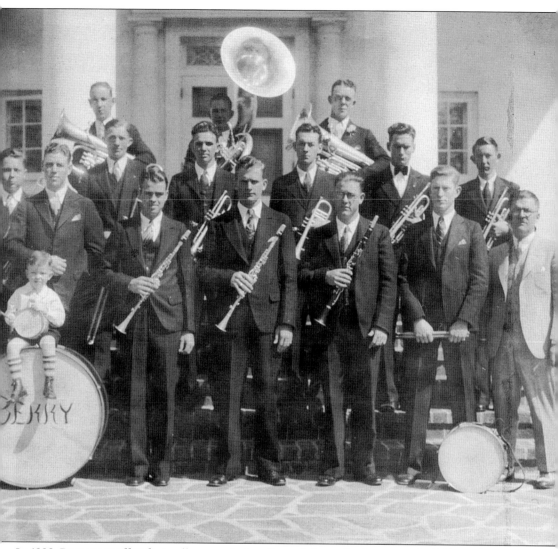

In 1932, Berry sent off its first college graduates after gaining collegiate status in 1930. Professor Ewing remained a vital part of the music department's success on the collegiate level. In the above picture of the 1932 band, note the group's newest member perched on the bass drum. Dicky Beyer is listed as the Berry Band mascot as well as snare drummer. Ewing directed not only the band but also the orchestra and concert choir, and he sponsored the Melody Club for several years. By the mid-1930s, the concert choir maintained a membership of over 40 voices. New groups also emerged, including a girls' school choir (later renamed the Cecilians), ladies quartet, church choir, and chapel choir. The Harmony Orchestra materialized out of a need for secular entertainment and played big band, swing, and jazz numbers. The statement "Everyone sings at Berry" was growing into an informal motto.

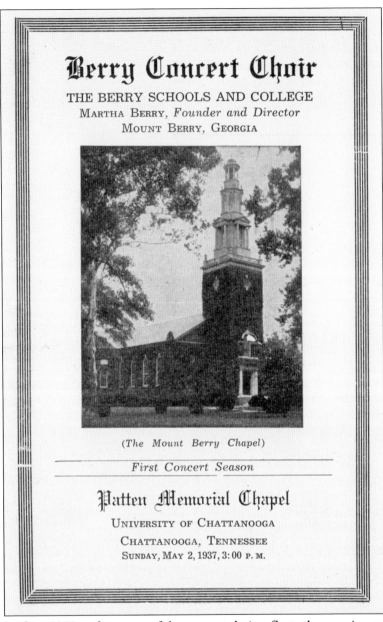

Berry Concert Choir

THE BERRY SCHOOLS AND COLLEGE

MARTHA BERRY, *Founder and Director*

MOUNT BERRY, GEORGIA

(The Mount Berry Chapel)

First Concert Season

Patten Memorial Chapel

UNIVERSITY OF CHATTANOOGA

CHATTANOOGA, TENNESSEE

SUNDAY, MAY 2, 1937, 3:00 P. M.

The program for a 1937 performance of the concert choir reflects the growing nature of the music program at the Berry Schools (both college and high school). The concert choir was the premier group to tour and travel. However, the concert choir was but one of Berry's five choirs. In 1937, the combined choirs performed over 125 times. Over half of the student body participated in one or more of the choirs. On the front of the program is a photograph of the College Chapel. The *Southern Highlander* noted that "it has long been one of Miss Berry's most cherished dreams to have beautiful and inspiring Chimes in our lovely chapel, and we do hope that this dream may be realized." Berry students built the chapel in 1915, and Martha Berry always sat on the front row of the balcony for services. On her 75th birthday, October 7, 1941, while on her deathbed, a group of alumni presented her the set of chapel chimes she so desired. It was the final gift made to her by the school.

Charles D. Beachsler was hired by Martha Berry to relieve Professor Ewing from his many duties. He arrived at the start of the fall term of 1936. Beachsler was largely assigned the duties of managing and directing the many choirs that emerged in the mid-1930s. Martha Berry recruited Beachsler from the Cincinnati Conservatory.

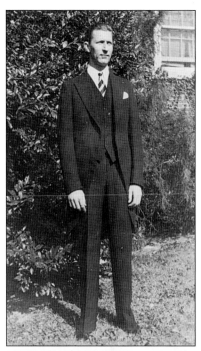

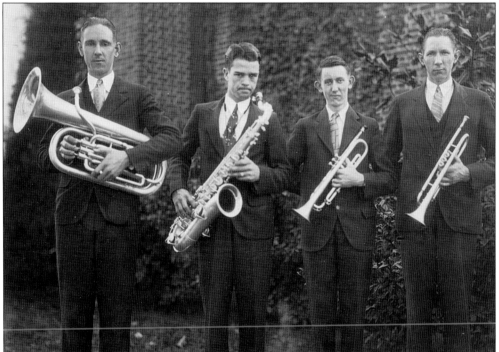

One of Martha Berry's greatest talents was her unmitigated effort to advance the school she founded. She was a tireless and masterful fund-raiser, appealing for financial support directly while also seeking donations for equipment and other supplies. Just four years before her death, Martha Berry convinced the owner of a music store to sell $1,000 worth of clarinets, horns, and trumpets for $200. Above stands a brass quartet from the 1930s.

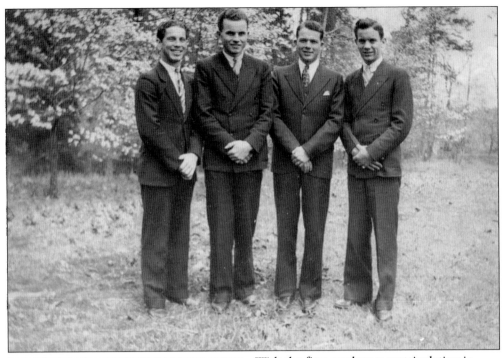

With the first graduates matriculating in 1932 from the newly accredited Berry College, enrollment increased throughout the 1930s. Throughout this time, Martha Berry received supportive correspondence from Franklin D. Roosevelt, Helen Keller, W. K. Kellogg, Mrs. Thomas Edison (Mina), Henry Ford, Mrs. Laurance Rockefeller (Mary), and Margaret Mitchell, to name a few. Her mission to provide an education that encouraged endeavors of the head, the hands, and the heart had garnered national recognition. By the end of the decade, the school's enrollment exceeded 1,000 students. Greater numbers and competition for acceptance led to the enhancement of Berry's musical groups. The 1937 men's quartet was particularly enjoyable and toured a great deal, locally and regionally. The members (above) were, from left to right, Loye Whitfield, Odis Riffe, Lloyd Amison, and Sidney Norman. At left, a concert program from 1934 features girls' ensembles led by Alice B. Warden, including the Ballad Girls and Warden's arrangement of the school "folk" song, "When I Came to Berry."

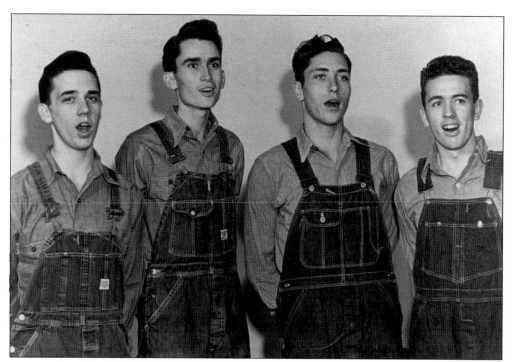

Despite gaining collegiate status and the authority to grant bachelor's degrees, the Berry Schools remained straightforward and traditional at heart. Boys still dressed in overalls to accommodate class and work, while female students wore uniforms. In 1940, all high school students were still required to take two years of music, and college coursework required musical training. However, course offerings increased to include rudiments of music, sight singing, music appreciation, history of music, history of orchestra, history of opera, oratorio, and harmony. Music was not a major, but according to the *Berry Schools Bulletin*, "college graduates who have specialized in music . . . will be given a special Diploma in Music with their degrees." Above, the men's quartet is pictured around 1948. Below, one of the girls' choirs sings around their teacher and accompanist, Alice B. Warden, in 1946.

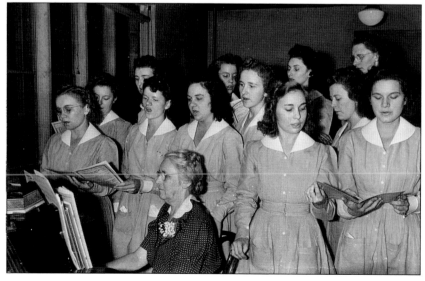

Band Concert

Directors

Halmer Wall—College Band
C. B. Keim—High School Band
John B. Hawley, assistant

Ford Auditorium, December 4, 1940, 7:30 P. M.

Program

Overture—Enchanted Knight	*Wheeler*
Waltz—Azure Skies	*Johnson*
Novelty—Military Escort in 5 Ways	*Bennett-Fillmore*
The original march	
As Mascagni might have written it	
As the "Waltz King" Strauss might have done it	
A modern Jazz version	
The Military Band on parade	
Duet—The Pals	*Barnard*
Randolph Green and Walter Russell, trumpets	
Idyl—Poppy Land	*Weidt*
March—Norembega	*Hall*

The Boys of the Old Brigade	*Parks*
A Little Close Harmony	*O'Hara*
Male Octet	

Overture—Au Printemps	*Arnold*
Sernade—Mingling Harmonies	*Wheeler*
Solo—The Flight of the Bumble Bee	*Rimsky-Korsakow*
Jimmy Harrell,clarinet—Jack Howard, acc.	
Song—Bells of St. Mary's	*Adams*
Carols—Deck the Hall	Old Welsh
Good King Wenceslas	Traditional
Brass Choir	
Characteristic—Une Promenade de Matin	*Bendel*
March— Stars and Stripes Forever	*Sousa*
Star Spangled Banner	

—*SOCIAL*—

Halmer Wall was the last music faculty member hired by Martha Berry before her death. Wall was a graduate of St. Olaf's College in Minnesota and served as the college music director from 1939 to 1943. Although music was required of all students and music had been a minor for years, the first major in music was developed in 1941. The major in public school music required 30 hours, with auditions for the program scheduled for the beginning of each term. At left, the program for the fall band concert, directed by Halmer Wall, reveals performances by the band, male octet, brass choir, and other groups. Carl Fischer music publications served as one of the leading publishers in the 1940s for orchestra and band scores as well as piano and organ collections. Berry often used their arrangements and compositions.

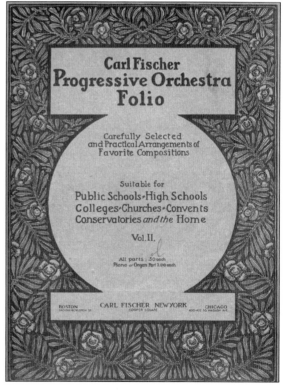

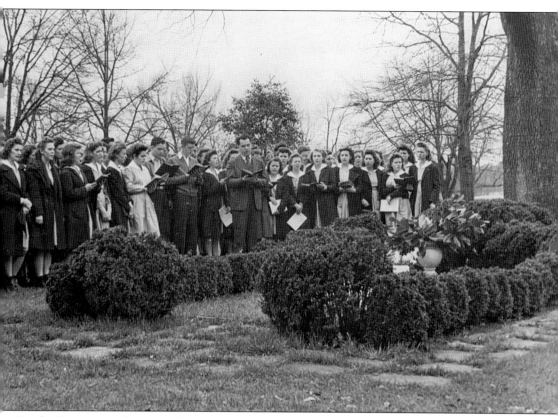

Martha Berry passed away in February 1942. She designated her final resting place on the south lawn of the main chapel because, as students marched into the chapel for service, the band stood there. Before her death, Berry expressed her wish that "the band not play any softer than they should." The simple tombstone, placed by alumni in May 1942, read, "Not to be ministered unto, but to minister." It was the motto that guided her life and vision for the school. In 1946, a pink dogwood, Berry's favorite tree, was planted by her grave in her honor. The passing of the school's founder and most ardent devotee created a void not easily filled. The small lady who first enticed mountain children with Bible stories and food in the late 19th century had become an educational pioneer, leaving all with her legacy. Martha Berry's burial service is pictured above, with Halmer Wall (center) leading the choir in song.

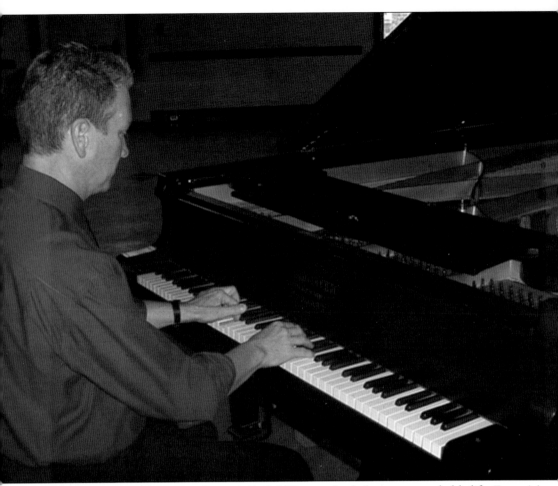

Martha Berry's eldest sister, Eugenia Enfield Berry, also led a very remarkable life. Eugenia's first husband, Henry Bruton of Nashville, Tennessee, served as the former head of the American Snuff Company. Upon his death in 1893, she inherited his estate. After several years as a widow, Eugenia married Prince Enrico Ruspoli of Rome, Italy. She purchased the medieval castle of Nemi in a small village near the Italian capital. With both Berry sisters living in very different cities bearing the same name (Rome), they continued to stay in touch. The Nemi castle's furnishings included an art collection and a Schiedmayer piano once used by the famous composer Claude Debussy. After the death of Prince Ruspoli in 1909, Eugenia divided her time between New York and Italy. As World War II approached, she shipped some of the furnishings from Nemi to Berry Schools. This included the piano, restored in 2007 by Berry alumnus Allan Gilreath. Several paintings remain on display at the Martha Berry Museum. Eugenia Berry Ruspoli died in 1951. Above, piano instructor Dr. Kris Carlisle plays the beautiful Schiedmayer piano in 2009.

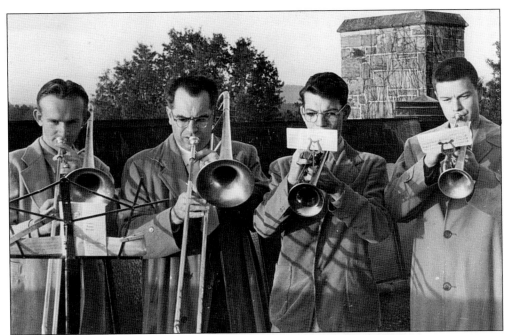

Maurice King became a new face on campus in 1943, shortly after the death of Martha Berry. King (second from left) came highly recommended, having studied and taught at the University of Cincinnati and the University of Michigan. His tenure at Berry from 1943 to 1954 came during a pivotal period in American history. King led the band as World War II came to an end, civil rights and the cold war began, and rock and roll developed as an enduring component of American culture. Yet the basic function of the school band remained rooted in tradition. The band played as students marched into chapel and also gave a short program as students assembled before every meal in front of Blackstone Hall. Some of the practices would fade by the late 1950s, but the college still boasted of its musical heritage, "Berry has always had a band. The idea is as old as the School itself."

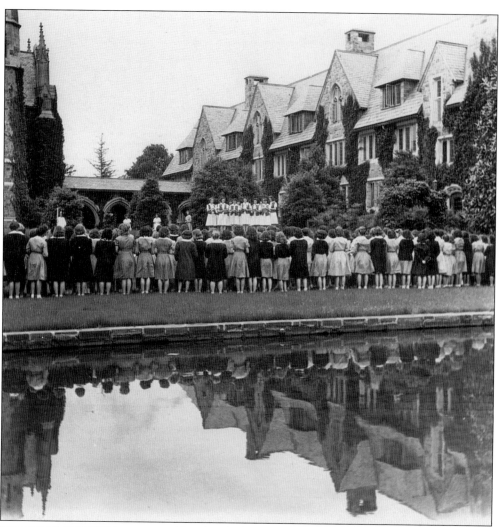

The Club Quadrille

Flute

Compiled and Published by Mr. Ford.
Not Copyrighted.

Ten days before Martha Berry's death, Henry Ford planted a magnolia tree on the grounds of the Berry Schools' Ford Buildings complex. Built in an English Gothic style, the Ford Buildings included Clara Hall and Mary Hall, both women's dormitories named in honor of his wife and daughter. Other buildings include Ford Hall, originally a dining hall, gymnasium, auditorium, and recitation hall. For many years, the Ford Buildings served as the epicenter for females attending Berry. Today Clara Hall and Mary Hall are still used for women's housing. Above, the girls' choir sings to the entire female student body, surrounded by the beautiful Ford Buildings in front of the reflection pool. Along with his donation to build the school's most impressive buildings, Ford continued to give money and other gifts. At left is an excerpt from an arrangement of the "Club Quadrille," which remains part of the Henry Ford Music Collection at Berry College.

50

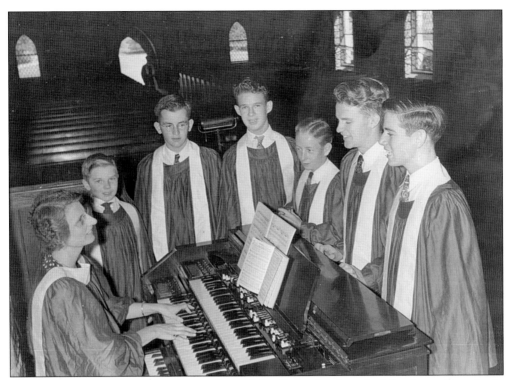

In 1948, the *Southern Highlander* proclaimed that "Berry has long had the slogan 'Everybody works at Berry' but it is just as true that everybody sings at Berry [too]. Even from the first little Sunday school in the log cabin Miss Berry played the melodeon and taught the children to sing." In fact, Berry College documentation shows that the first music appreciation classes in the state were taught at Berry. In the first image, members of the 1948 boys' choir practice for an upcoming chapel service with their accompanist, Marguerite Pierce, wife of Prof. Harry Pierce, on the organ. In the second photograph, the chapel choir leads the congregation out of the College Chapel after a service.

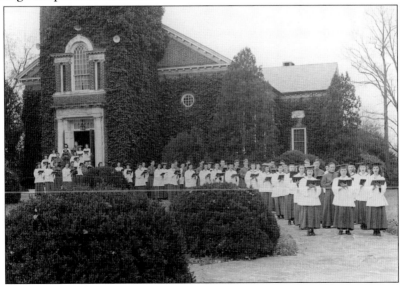

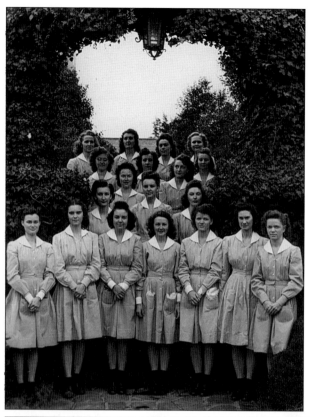

An earlier description of the choral department in 1938 also proclaimed, "No one questions the statement that 'Everyone sings at Berry' after attending a Joint Chapel service . . . where the entire student body may be heard joining in the haunting strains of 'Jacob's Ladder' and other songs. The Christmas Carol Service and candlelight serenades, in which all students participate, are additional proofs of the distinctive place music has in the soul of our institution." For several years, the *Cabin Log*, Berry's yearbook, even stated, "Not being a music school does not prevent Berry from being a musical college." At left stands the 1946–1947 girls' choir. Pictured below, the 1949 concert choir poses for its annual photograph.

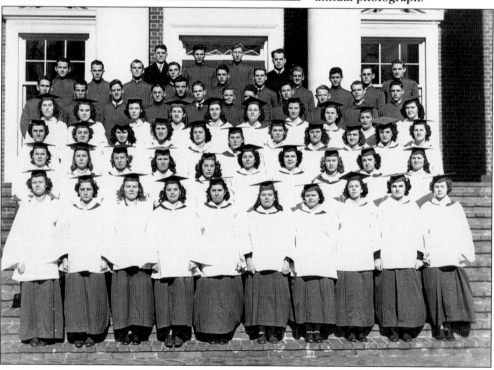

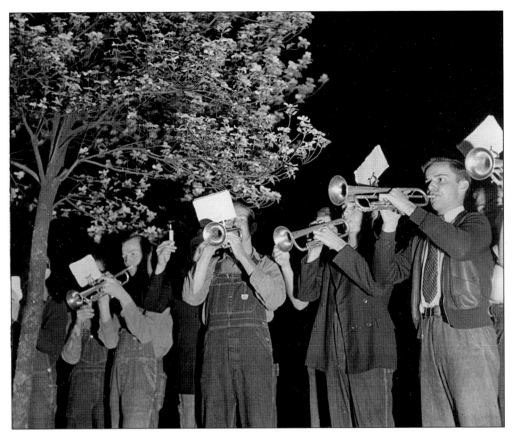

Beginning in 1946, music was listed as part of the general studies, which also included business, fine art, English/speech, modern languages, journalism, and physical education. Here the band plays for a school pep rally.

The Cecilians emerged as a new group in the 1940s under the direction of Alice Warden. The Cecilians described themselves as "a group of closely associated college girls banded together by their love and appreciation of music." Pictured at right is the 1948 group, including professor emerita Dr. Ouida Word Dickey (back row, third from left).

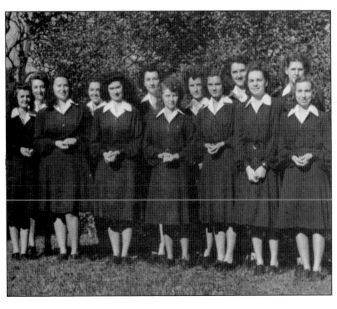

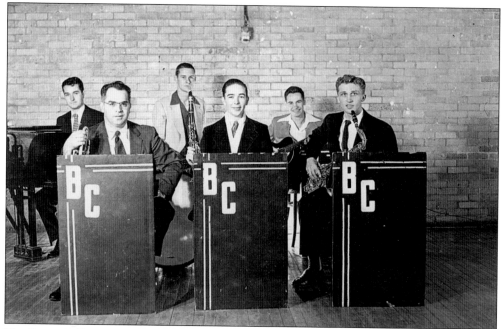

The Berry Collegiate formed in the early 1950s. The decade after World War II brought with it a new sense of prosperity to the United States along with an explosion of musical legacies such as Elvis, Frank Sinatra, Johnny Cash, and Nat King Cole. Rockabilly combined country, jazz, and big band varieties into the burgeoning rock and roll genre. Maurice King (front left) served as director and founding member of Berry's new jazz and rock group.

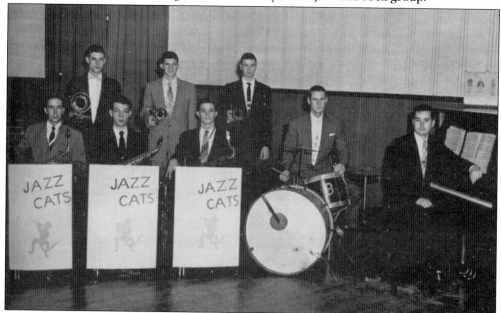

In 1952, the group's nickname became the Berry Cats, and by the mid-1950s, the group was affectionately known as the "Jazz Cats." As athletics became more popular, the band sometimes filled the role of a pep band playing at basketball and baseball games. Here the Jazz Cats pose for a picture in 1954.

In 1952, the Berry Schools celebrated its 50th anniversary. The Berry musical groups served as the most visible (and audible) part of the school's golden anniversary. The music department faculty also added two new faculty members. J. J. Coleman, who studied and taught at Valparaiso University, the University of Chicago, and the University of Southern California, came to the school as a music instructor. Maurice King was also joined by his wife, Lois King, on the faculty. Mrs. King completed her musical training in Cincinnati. Along with new faces on the music faculty, a familiar face resurfaced. The beloved Prof. M. C. Ewing returned to campus. Ewing returned to the music program but also for a new love interest. After the passing of his first wife, he married Bertha Hackett, who had long served as the secretary to the registrar and to Dr. S. H. Cook. Pictured above is the 1954 Melody Club with Maurice King (seated left) and Professor Ewing (seated right). Pictured below is a female student performing her student recital on an accordion.

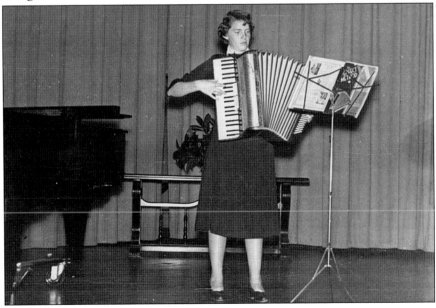

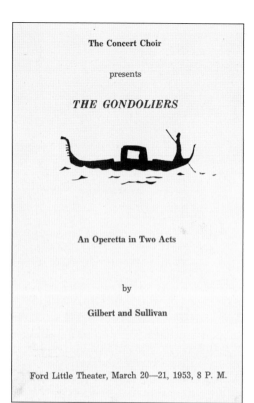

The Concert Choir

presents

THE GONDOLIERS

An Operetta in Two Acts

by

Gilbert and Sullivan

Ford Little Theater, March 20—21, 1953, 8 P. M.

The concert choir program exhibits the musical repertoire of the music program. Performing in the Ford Theater, the choir sang one of Gilbert and Sullivan's more popular operas, *The Gondoliers*. W. S. Gilbert was a librettist and Arthur Sullivan was a composer, and they collaborated to write over a dozen light operas during the late 19th century. Perhaps their most famous remains *The Pirates of Penzance*.

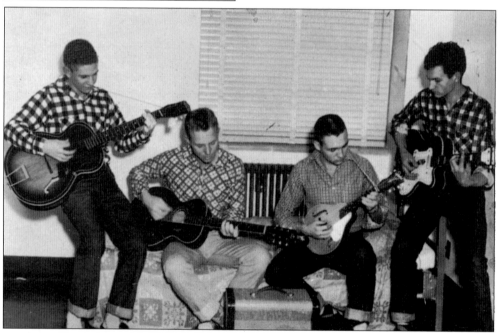

However, the Berry Schools did not abandon their Appalachian roots. Pictured above, four traditional students play bluegrass tunes in their dormitory room on campus. In the 1956 *Cabin Log* feature "Music Snaps at Berry," the caption reads, "Gilbreath, Willis, Daugherty, and Connell are in 'Hill Billy Heaven.' "

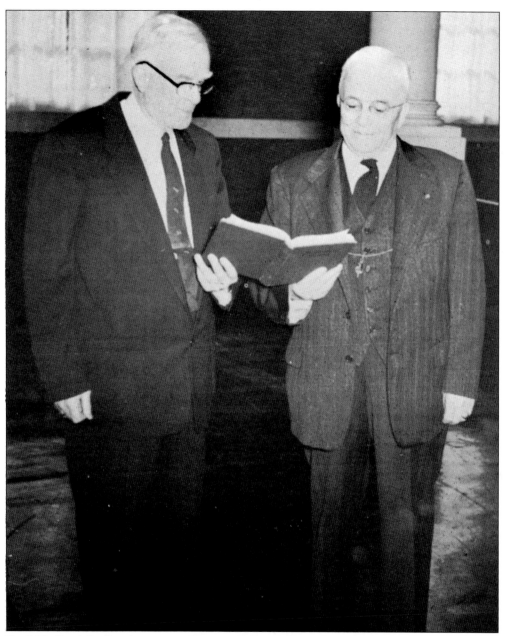

Dr. S. H. (Sam) Cook, who came to Berry in 1910, taught mathematics, physical education, and coached, but later became Berry's longest serving dean. He also served as interim president in 1951 and 1952. In sum, Cook's tenure spanned over 50 years. The Cook Building was named in his honor and housed the science department until the late 1990s. Presently it serves as the home of the Charter School of Education and Human Sciences. Also instrumental in the school's history was Dr. Leland Green, the first president of Berry Junior College, established in 1926. The Green Building is named in his honor and houses the Campbell School of Business. Dr. Green also wrote a song entitled "Berry." Pictured above are Sam Cook (left) and Leland Green (right) singing in chapel in 1958. Both men remained advocates of music at Berry during their tenures.

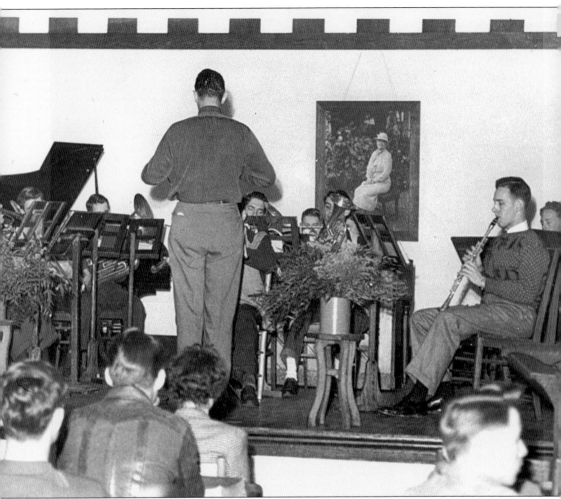

W. M. Goodson assumed the directorship of the band from 1956 to 1959 and was the church organist. Goodson also became the first music faculty member who was an alumnus of Berry. Goodson left Berry to continue his graduate studies at Emory University in Atlanta. He donated the Steinway grand piano currently in use in the College Chapel in 1995. Above, Goodson directs the band as it plays for an audience, including the late Martha Berry, whose portrait watches over the performance.

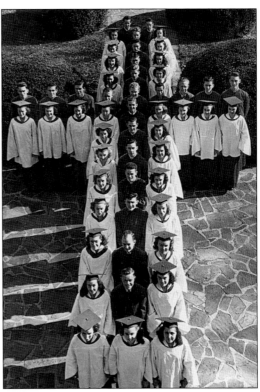

The concert choir poses in the mid-1950s for a picture outside the chapel steps. The choir continued to maintain strong numbers and sang at every chapel service. Although the school did not maintain ties to any specific denomination, religious service remained a cornerstone of the "Berry Way." Below, the male quartet of 1954 sings under the beautiful ivy-covered arch of the Ford Buildings. The male quartet was perhaps the first musical group established at Berry, singing continuously from the early 1900s through the 1950s. However, in the 1960s, the a cappella group seemed to lose its prominence and appeared only sporadically over the next two decades.

Maurice King poses with the college's girls' ensemble in 1954. The 1953 *Southern Highlander* continued to ask for band instruments as well as pianos, radios, and other music supplies. Although Berry's music program was an instrumental part of college life and the local community, instruments and equipment remained expensive.

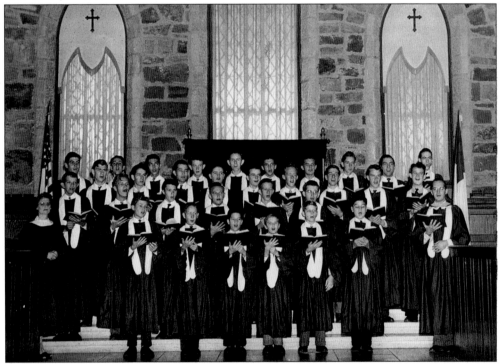

The boys' high school choir was formed in the 1930s and continued to sing for special chapel services and other events. The girls' high school choir, which formed at the same time, was forced to disband. In May 1956, the Martha Berry School for Girls closed its doors. Female groups would continue on the collegiate level.

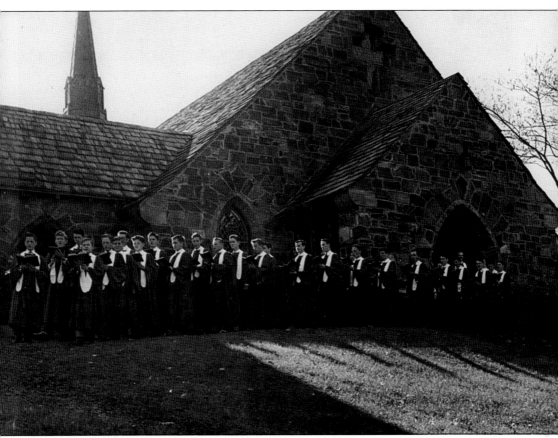

Frost Memorial Chapel is one of the school's most treasured landmarks. Martha Berry desired a chapel on "Mountain Campus," approximately 4 miles from the main campus. Mountain Campus was also the site of Martha Berry's first formal school building, known as Possum Trot, where the community renovated and added classrooms to an abandoned church in the 1890s. In the 1930s, Mr. and Mrs. Howard Frost of Los Angeles, California, visited campus and attended a crowded worship service in the recitation hall. While touring Mountain Campus, they saw a small cross atop a hill, bearing the words "Chapel needed." The Frosts donated the funds for the chapel and named it in their son's memory. Frost Chapel has been used as a site of special services for nearly 75 years and maintains breathtaking stonework, stained-glass windows, and high wood-beam ceilings. Above, the boys' choir leads the congregation after a service in the late 1950s.

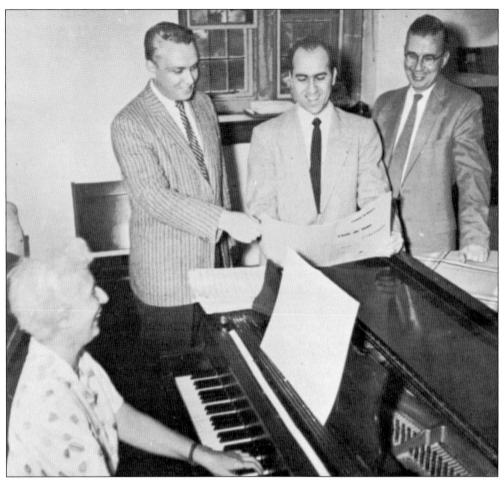

The late 1950s revealed a bit of instability in the music department. The curriculum continued to require music of all students and offered a major in music. All sophomores were required to take music appreciation, music majors studied piano for a minimum of two years, and music minors performed in at least one public recital per year. Maurice and Lois King departed Berry after 12 years, and M. C. Ewing retired. W. M. Goodson was appointed head of the music department but remained only three years. Constance Ohlinger also served on the faculty for four years and assumed the duties of the late Alice B. Warden, including the Ballad Girls and chapel pianist/organist. Above is the music faculty in 1958 with, from left to right, Constance Ohlinger, Homer Savige, Ross Magoulas, and W. M. Goodson. Pictured at left, Ohlinger plays piano.

Three

FORTISSIMO
1959–1976

As the 1950s passed and the school entered the 1960s, music making at Berry School experienced both good and bad changes. The end of the decade that "liked Ike" also signaled the end of an era at Berry, which saw certain traditional elements fade in the name of progress. Social activist movements, led by a new generation of college students, included civil rights, counterculture, women's liberation, and anti-war protests. Berry College remained largely unaffected by such movements of social change; however, the makeup and outlook of the student body did experience a transformation of sorts. In 1959, Berry admitted its first international student, and its first African American student was admitted in 1964. Women at Berry also broke gender barriers, pursuing majors and student jobs typically reserved for males. School uniforms and required daily chapel were both abolished in the 1960s, and the dress and style of students certainly changed in the 1970s. The Mount Berry School for Boys changed its name to Berry Academy and admitted female students.

The "Swinging Sixties" brought a period of decline for the band, while the choir and the newly formed Berry Singers entered a time of notoriety and achievement. Homer Savige assumed the duties of department head and also band director. Jonnie Dee Riley arrived to direct the girls' singing groups, and Howard Thorson directed the high school boys' choral program. Ross Magoulas and accompanist Louise Haack-Strong led the Berry College choirs into unchartered territory in the 1960s and 1970s, expanding the repertoire and touring schedule. In 1968, Darwin White became the new department chair, and Berry received accreditation through the National Association of Schools of Music. In large part, accreditation and the subsequent increase in music majors led to a new assemblage of music faculty. By the 1970s, Berry music had regained its role as a vital part of campus life. As the 1971 *Cabin Log* affirms, the "interpretations of this life with its staccato ups and downs and quiet melodies are reflected in music. [Berry music] resurrects penned melodies . . . they have made music a part of our [school] rhythm of life."

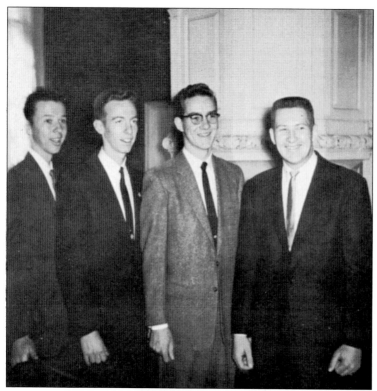

As the rock and roll craze swept America, Berry also caught the wave. Pictured at left are the 1958 Berrytones, who started in 1957. Another group of students formed the C-Notes in 1958 (below). These groups played for school events but also booked outside gigs throughout northwest Georgia. Musical groups at Berry College had certainly changed from the days of formal wool uniforms and marching bands.

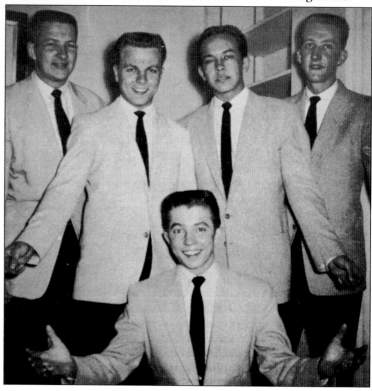

In 1957, John R. Bertrand became Berry's fifth president. Bertrand completed his doctorate of philosophy at Cornell University. In his inaugural year as president, Berry College received full accreditation from the Southern Association of Colleges and Schools as a four-year college. Bertrand continued in the tradition of past Berry presidents, as he strongly supported the music program in general. Bertrand served as president until 1980.

In 1959, the Department of Music faculty included Homer Savige (left), Jonnie Dee Riley (center), and Howard Thorson (right). Jonnie Dee Riley was from the University of West Virginia and Cincinnati Conservatory. Howard Thorson studied at the New England Conservatory of Music. Although Riley and Thorson came to Berry at a pivotal time in the college's history, neither remained more than three years.

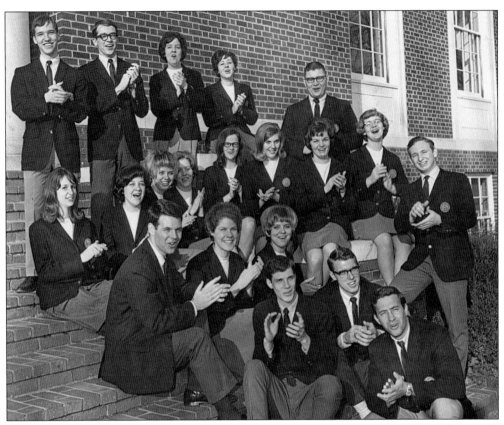

In 1958, a new musical ensemble formed. The Berry Singers were comprised of students with exceptional vocal talent. The group was much smaller than the concert choir, although some students sang in both groups. In terms of musical course offerings, students could minor in music education, applied music, piano, or voice. According to the catalog, 18 hours were required to minor in music. Throughout the late 1950s and early 1960s, Berry offered an average of 12 music courses. Additional credit hours could be earned through membership in musical ensembles. Here, the newly formed Berry Singers pose for pictures.

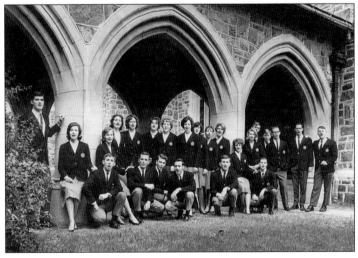

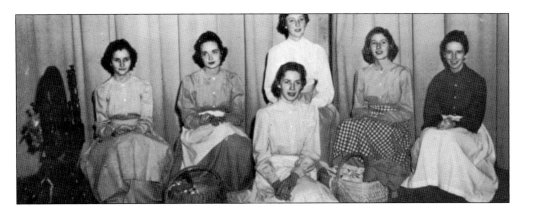

The Ballad Girls had long been a part of Berry, but the group's last performance season ended in 1960. Luci Hill Bell, a member of the 1960 Ballad Girls, remembers Constance Ohlinger as the director for most of her time at Berry. In their final year, the group traveled to Jekyll Island, Georgia, and performed on a television program in Atlanta. Bell commented that many of the girls also worked at the guest cottages, where they not only cooked and served guests but also "took off their aprons and sang" after dinner. Many were disappointed that the group disbanded, because the group was great fun, and the girls enjoyed singing folk songs while carding wool and working the spinning wheel. It was the end of an era at Berry. Pictured here are the 1959 Ballad Girls.

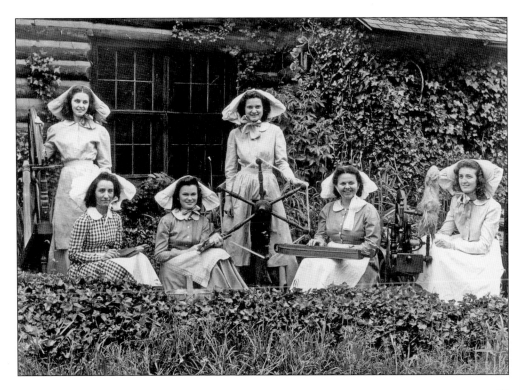

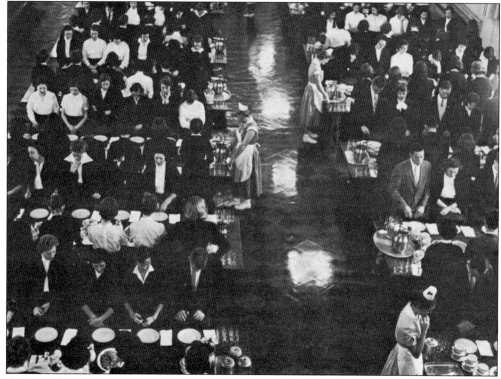

By the 1940s, students at Berry dined in both Blackstone Dining Hall and Ford Dining Hall. In the 1960s, Blackstone Dining Hall closed, and the band ceased to play as students marched in to eat. Pictured above, students eat in the elegant Ford Dining Hall in 1961.

Each Christmas season, the choir performed Handel's *Messiah* as part of the Christmas program. This tradition began as early as the 1920s. Programs varied from year to year; however, Handel's *Messiah* remained the focal point of the Christmas program for over 50 years. Here 1960 *Messiah* soloists—from left to right, Bernard Todd, Norma Weather, Annette Hulme, and William Copenhaver—pose before the performance.

From 1958 to 1960, Howard Thorson served as a general music instructor and directed several ensemble groups. General music courses sought to teach an appreciation of music with basic instruction on instruments such as the autoharp, recorder, and piano. New ensemble groups of the late 1950s included the Mixed Quartet, the Miraclettes, a dance band, and the Rebel Rock 'n Rollers. Above, Thorson teachers a general music class in 1959.

Pictured at right, Homer Savige rehearses with the Berry College band. The 1959 *Cabin Log* stated that Berry made "merry music of harp and horn." In the early 1960s, the band room was situated in one wing of Memorial Gymnasium. In 1972, the music department was given a more centralized space for classes and rehearsals in the Hoge Building (the school's first recitation hall).

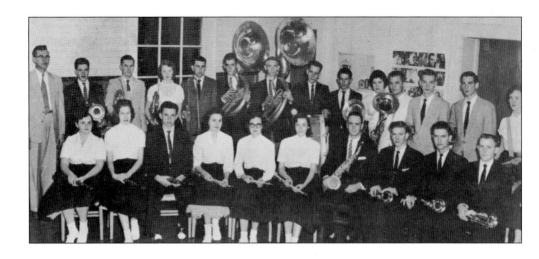

Homer Savige studied and taught at Pennsylvania State University and Florida State University. He brought a level of intellectualism to the music department and was well respected within the Berry community. However, serving as department chair and band director proved too much for Savige to handle. While incredible musical guests and groups visited campus at the behest of Savige, the band dwindled to numbers more appropriate for a musical ensemble rather than college band. Pictured above is the band in 1958, just before Homer Savige became the director. Interestingly, the late 1950s brought a change to the face of the band, as the school allowed women into the group for the first time. Pictured below is the 1962 band with Homer Savige (left).

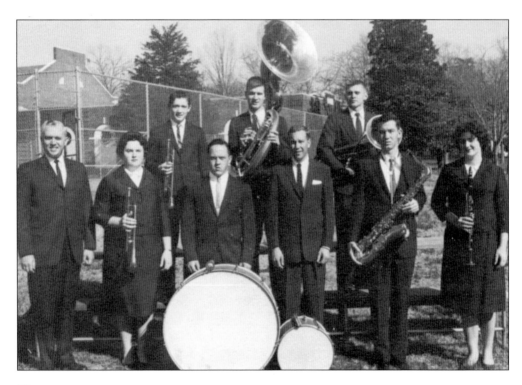

Joe Walton, class of 1962, was part of another fundamental shift in higher education as many schools abandoned strict uniform requirements. Berry College followed this national trend, as the school abolished required uniforms in 1962. Daily chapel services also became voluntary. Musical ensembles continued to perform in chapel; however, school music groups no longer sang at every service and the band only performed on special occasions. Berry continued to require student work through on-campus employment, but daily demands did relax to an extent. The school compromised student work outside the classroom in exchange for higher standards inside the classroom. J. Battle Hall, 1959–1960 president of the alumni association, recollects that work requirements were modified to two days of work per week. Most students attended classes Monday through Thursday and worked on Friday and Saturday.

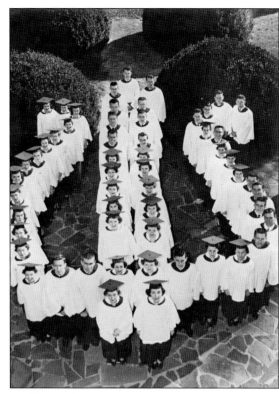

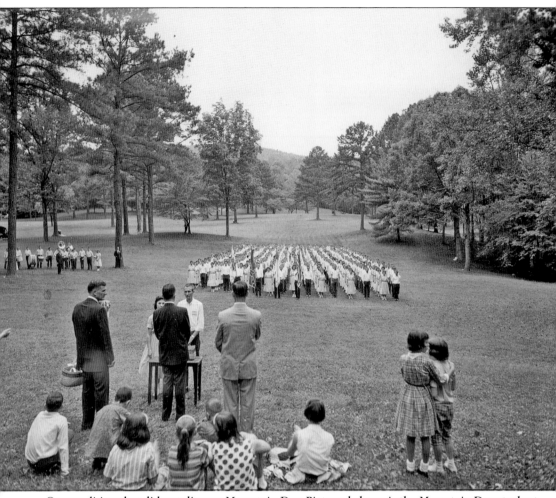

One tradition that did not die was Mountain Day. Pictured above is the Mountain Day student march in 1960 with the band providing the music. In 1965, the *Campus Carrier* wrote, "Traditions spring from many sources. . . . The tradition of Mountain Day is one which came from the Berry students themselves. To these, the earliest Berry students, the chance to get an education meant more than it seems to mean to many today. To them the Berry Schools was not only a chance, but in many cases, the only chance. From this gratitude sprang a campus tradition. The original idea was for the students to pool their money and buy Miss Berry a gift on her birthday. However, the founder of the school rejected the idea. If a gift were to be given she desired donations for her beloved school. . . . Students formed the idea of a Grand March dropping their contributions into a basket as they passed. The rest of the day was devoted to sporting events, [music], and a picnic. A tradition was born."

The TRAPP FAMILY SINGERS

First Sopranos	First Altos
Agatha von Trapp	Martina von Trapp
Johanna von Trapp	Hedwig von Trapp
Second Sopranos	**Second Alto**
Maria von Trapp	Baroness Maria von Trapp
Rosmarie von Trapp	**Baritone**
Eleonore von Trapp	Dr. Franz Wasner

Dr. Franz Wasner, Conducting

PROGRAM

I

Pueri Hebraeorum *Palestrina*
Over the Mountain Mary Went *J. Eccard*
Ave Maria .. *Mozart*
Psalm No. 23 (The Lord is my Shepherd) *Schubert*

II

Two movements from Sonata in B flat *Telemann*
(*for alto recorder and virginal*)
Dolce—Vivace
Two movements from Sonata in C major *Mozart*
(*for three woodwinds*)
*Adagio—Rondo

III

Sing we and chant it *Thomas Morley*
Bed is cozy *Canon by Mozart*
Spinning Song (Austrian Folk-Song) *arr. by A. Aslanoff*
Three Austrian Folk-Dances *arr. by F. Wasner*
(*for recorders and virginal*)
Intermission

IV

Carols *arr. by F. Wasner*
Hirten auf um Mitternacht *Austrian*
Angels we have heard on high *French-English*
Jesus, rest your head *from the Kentucky Mountains*
Tu scendi dalle stelle *Italian*
Es hat sich heut eroffnet *Tyrolean*
The Virgin's Lullaby *Tyrolean*
Silent Night *F. Gruber*

Victor Red Seal Records Repertoire published by G. Schirmer, Inc., New York
Tour Direction: **METROPOLITAN MUSICAL BUREAU, INC.,**
DIV. of COLUMBIA CONCERTS, INC.
113 West 57th Street New York 19, N. Y.

In 1966, Berry had the honor of hosting Baroness Maria von Trapp and family. Her life inspired the character played by Julie Andrews in *The Sound of Music*. In reality, Maria married Baron von Trapp and became stepmother to his seven children. On the brink of World War II, the family fled Austria in defiance of Nazi invasion. Their story was put to music by Rodgers and Hammerstein, composers and writers of the hit musical, which later became the iconic film. After bearing three children of her own, Maria von Trapp and her 10 children became the Trapp Family Singers. After the baron's death in 1947, Maria became the head of the household. She became a U.S. citizen in 1948 and was awarded the Gold Medal of Merit in Austria. Starting in the mid-1950s, members of the family eventually "toured the world for twenty years, winning acclaim in more than 2,000 concerts [across] the United States, Europe, Australia, and New Zealand," according to Berry's *Campus Carrier*.

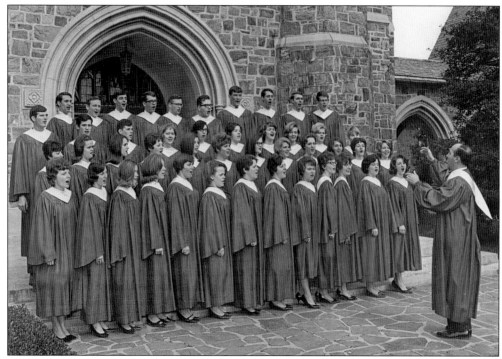

Above, Ross Magoulas directs the choir in front of one of the Ford Buildings. Below, Magoulas stands with fellow faculty member Haack-Strong while students Bill Supon and Christine Puckett stand around the piano. Haack-Strong earned her master of music degree from the University of Michigan, while Magoulas earned his master of music from Florida State University. Promoted to associate professor of music, Ross Magoulas received praise from "numerous critics and musicians as a gifted choral director, and [was] in constant demand as a conductor and clinician," according to Berry's *Campus Carrier*. When asked about his professional career, Magoulas enthusiastically commented, "My 26 years at Berry was a beautiful time in my life. It was a great learning experience for which I am most grateful. I am fortunate to have met wonderful friends, colleagues, and most importantly my loving and lasting friendships with so very many of my former students, aka 'my chirrun.' "

The 1960s represent a decade of change, growth, and greater equity. As social movements swept the nation, the makeup of colleges and universities changed. Berry's student body also changed as a result of the civil rights and the women's movements, which both came to fruition in the 1960s. Berry's first African American student was admitted in 1964. Above, one of Berry's first African American students plays in the jazz band in 1968. Caucasian women had long been a part of the Berry Schools after Martha Berry added a girls' school in 1909. However, the role of women greatly expanded in the 1960s, as it became socially acceptable for men and women to sit together in the dining hall and chapel and join clubs and ensembles that were previously open to males only. Women joined the Berry Band for the first time in the 1960s, and as shown below, females also began playing instruments in the concert band, traditionally reserved for males.

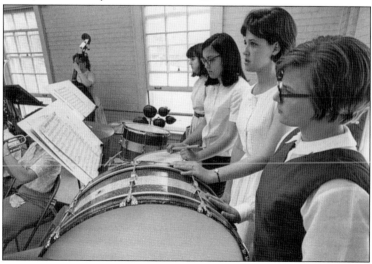

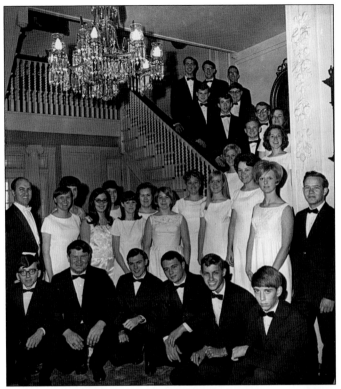

The early 1960s proved a busy time for the Berry Singers and concert choir. As one article in the *Mount Berry News* noted, "Should you see a person standing against a building, sleeping between classes, or wobbling to and fro down the sidewalk, don't make a hasty decision; he is a member of the Berry Singers!" The group traveled widely throughout the southeast. Here both groups pose on the grounds of Oak Hill, Martha Berry's family estate.

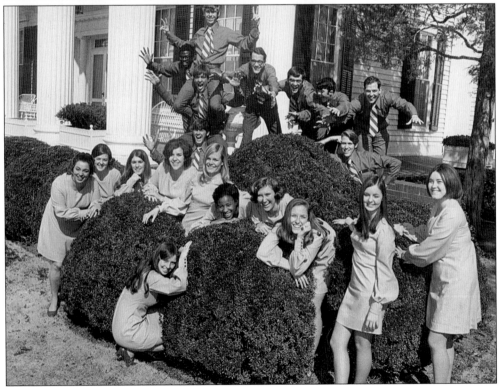

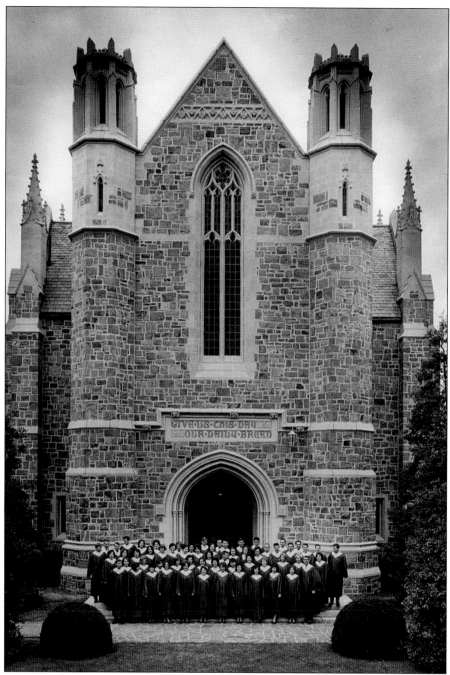

The Berry College Concert Choir released its third recording in 1963. Processed by RCA, the record featured two choruses from Handel's *Messiah*, "Go Not Far From Me, O God" by Zingarelli, "The Last Words of David" by Thompson, "Glorious Everlasting" by Cousins, and "My God and I" by Sergei. Officers for 1963 included Wesley Martin, David Butler, Penny Vaughn, Susie Cook, David Sanford, Koji Yoda, George Sharpe, Larry Johnston, Phillip DeMott, Virginia Kell, Ruth King, and Jimmy Tucker. Pictured above is the 1963 concert choir in front of one of Berry's most picturesque buildings, Ford Dining Hall.

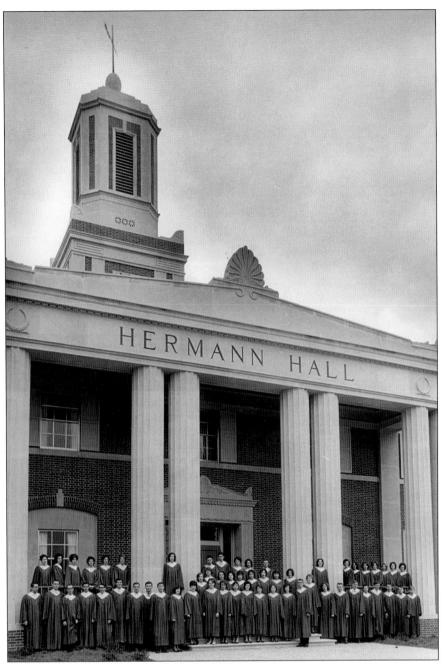

Above, the 1964 concert choir stands in front of Berry's newest building, Hermann Hall. Construction began in 1962 with funding provided through a gift from Grover M. Hermann, a prominent Chicago businessman. The building was fully operational by 1965. Today Hermann Hall serves as an administration building and also houses the registrar's office. The main campus entrance originally led to the Hoge Building with a long driveway lined with oak trees. In the 1960s, with the construction of Hermann Hall, the main campus entrance shifted. The current Gate of Opportunity opens to distant views of Hermann Hall, which now provides visitors with their first impression of Berry College.

The choir tour of 1963 included performances in Florida, South Carolina, and Georgia. Choir member Russell Long recollected, "One of the highlights of the whole tour came when the choir had an opportunity to sing in the Citadel Chapel. The acoustics were perfect." As Long nostalgically recalled the end of the trip, "[A]s we entered the Gate of Opportunity, we remembered the week before when our buses were headed in the opposite direction. As we thought back, we were filled with an inner calmness that comes only when you've completed a job well done." At right, the choir is welcomed as they arrive in Jacksonville, Florida. The group also performed for television in Columbia, South Carolina, on the tour. Below, the Berry Singers practice for the upcoming tour of 1963.

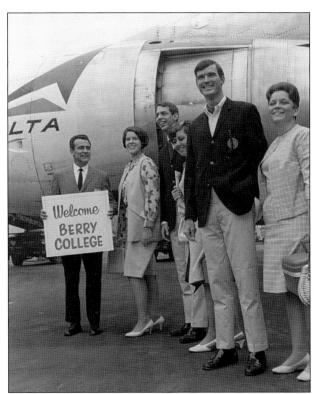

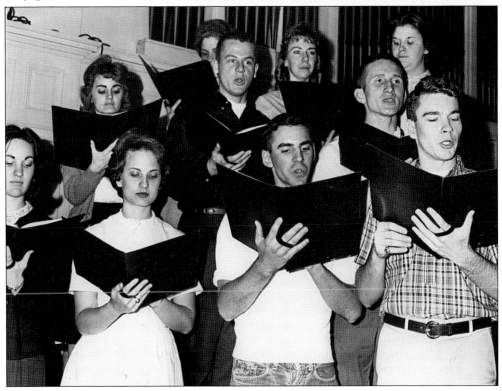

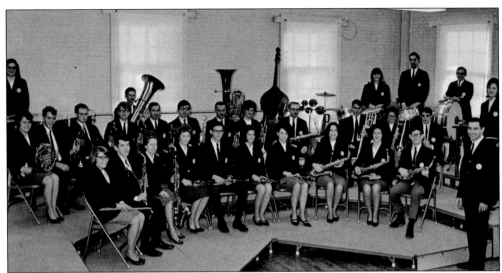

In 1967, the Berry Band began a new chapter under the directorships of Charles Lawson (1967), Robert Humphrey (1968–1969), and Jim Clark (1970–1985). As the 1967 *Cabin Log* commented, "The face of the Berry Band underwent quite a change this year. Berry brought in Mr. Charles Lawson [far right]. . . . A director of considerable drive, [he] not only sharpened the band, but recruited for Berry Bands of the future."

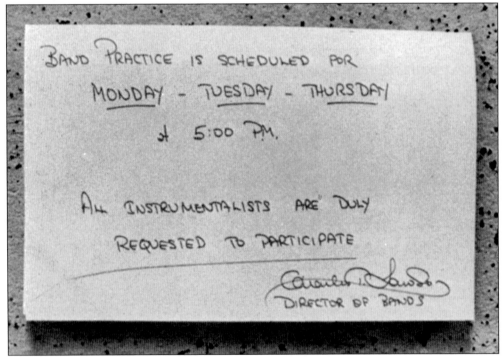

Charles Lawson revitalized and reorganized the band, making instrumental music the center of school culture once again. With Lawson injecting new energy into the band program, the group played for athletic events and performed regular concerts. One student noted, "To us it was an exhilarating thing, seeing the band come to life." Above, Lawson's short tenure took effect as he reshaped the professionalism of the band with wit and humor.

Berry College offered its first summer music camp in July 1963. Department chair Homer Savige used the camp to attract local community members and to give Berry faculty and music students the opportunity to teach courses. The two-week camp included classes for jazz, conducting, and songwriting. In addition, campers participated in at least one music ensemble. At the conclusion of the session, the camp musical ensembles gave performances.

SUMMER MUSIC CAMP

July 8-18, 1963

at **BERRY COLLEGE**

Mount Berry, Georgia

CHORAL WORKSHOP
PRIVATE LESSONS

In the spring of 1964, the "Berry Choir sample[d] seasons as they harmonize[d] for over 1600 miles." The culminating event came as they sang a special service at the National Cathedral in Washington, D.C. The choir gave a full concert of 15 anthems, and the event made the *Washington Post*. An additional highlight was a trip to the Capitol to meet then-congressman John Davis (fourth from right, second row).

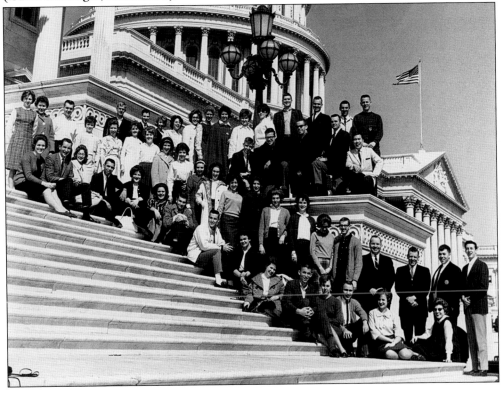

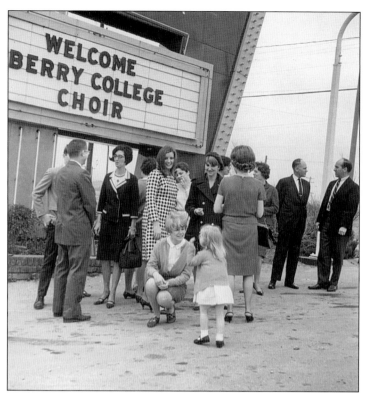

In 1964, the Berry College Concert Choir embarked on a tri-state tour. The 60-voice choir appeared before churches, high schools, club groups, and on television. In the newly renamed student newspaper, the *Campus Carrier*, Ross Magoulas commented, "I think that this is good public relations for the school, a chance [to connect with] Berry alumni, [and visit] other schools and organizations." At left, the Berry Choir stands in front of a theater marquee in Savannah, Georgia. Below, the city of Foley, Alabama, presents the choir with a key to the city.

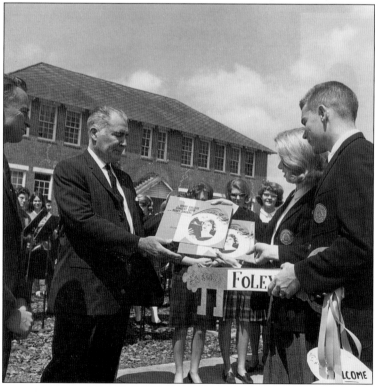

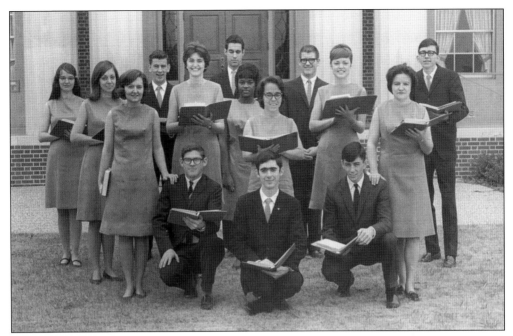

The Berry College Concert Choir and Berry Singers continued to gain notoriety both on and off campus. In 1969, one member of the school community wrote that "they are the finest ambassadors of Berry College . . . reflecting in the quality of their performances and the dignity of their bearing not necessarily what Berry is or has been, but what it can become."

By 1968, the band program experienced continued growth under the direction of Robert L. Humphrey. Pictured at right, the 1968 music department promotes new growth and musicianship. The Berry Singers and Concert Choir continued to tour throughout the country with a repertoire the Music Department reported was "chosen primarily from great historical and contemporary choral literature." Band options also expanded with a larger Berry Band, a Berry Brass Choir, and a revitalized pep band under Humphrey.

THE BERRY COLLEGE CONCERT CHOIR

THE BERRY SiNGERS

THE BERRY BAND

BERRY COLLEGE
MOUNT BERRY, GEORGIA 30149

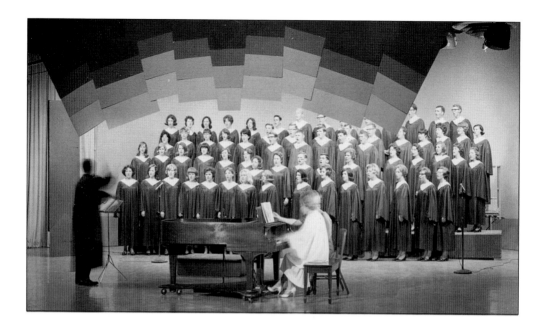

According to an article entitled, "Our Goodwill Ambassadors . . . 1966 Style," in the *Berry College Bulletin/Southern Highlander*, "Berry always has had good will ambassadors who have taken a bit of the institution to places near and far, making new friends wherever they went." The 1966–1967 school year was particularly busy, with several groups touring. The concert choir, with 66 voices, presented 13 concerts and made three television appearances in a weeklong, 1,800-mile concert tour. Pictured above is one of their television appearances for Atlanta's WFGA-TV channel. As a smaller and more selective group, the Berry Singers gave nearly 20 concerts, including a performance in the Atlanta Pops Concert Series. A promotional picture of the 1968 Berry Singers is featured below. The promotion reads, "Their performances naturally are awaited eagerly by alumni who have a deep pride in . . . their school. [Alumni] are joined by others who enjoy the fine entertainment so greatly that they become interested in Berry and develop into warm friends."

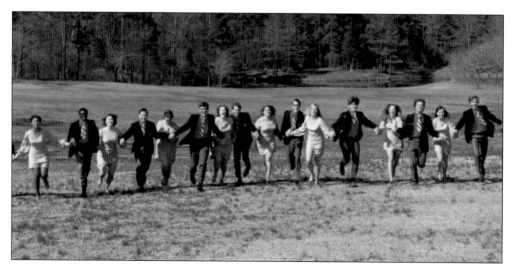

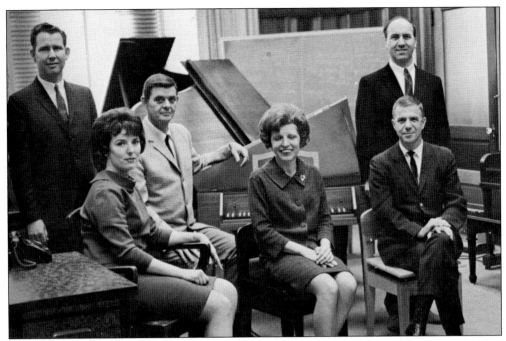

The Berry music department reached a major milestone as it earned associate membership in the National Association of Schools of Music (NASM). Full membership was obtained three years later in 1972, allowing Berry to grant bachelor's degrees in music. In large part, Dr. Darwin White served as the driving force behind Berry's accreditation. White received his master's and doctorate from Vanderbilt's Peabody School of Music. He was hired in 1968 as the new department chair of music and quickly moved to begin the process of accreditation. Before application, White completely revised the music curriculum, adding several music course offerings. In addition, White worked with Berry administrators to expand the number of full-time faculty members. In sum, the number of full-time faculty members in the music department increased from three in 1968 to eight by 1972. Below, Dr. White (right) stands holding the NASM membership certificate. The music faculty of 1969 (above) is, from left to right, Darwin White, Louise Causey, Robert Humphrey, Louise Haack-Strong, Ross Magoulas, and Ken Josephson.

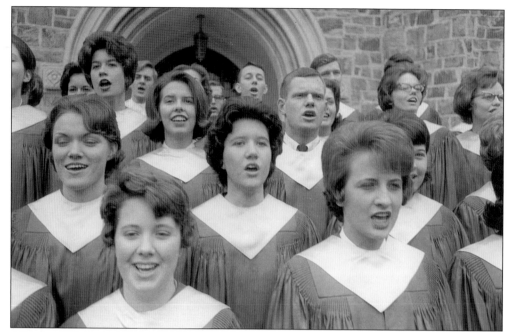

The accreditation process was made possible, in part, because of the work of Ross Magoulas. The Berry College Concert Choir and Berry Singers became ensconced under Magoulas's leadership. These choir ensembles toured extensively, performed often, and developed a strong regional following. As one student commented in 1969, "No one knocks the choir . . . for the choir's success symbolizes the excellence potentially within us all."

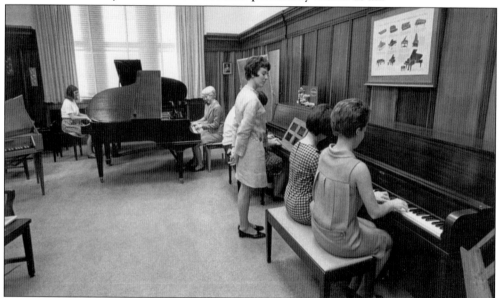

Louise Causey (above) was one new faculty member added in the late 1960s. Other events also helped Berry's application to NASM, such as the Annual Fine Arts Festival, which began in 1967. This event not only showcased Berry ensembles but also brought renowned musical performers and groups to campus. With NASM accreditation, Berry attracted more students interested in music. By 1969, the number of majors had increased to its highest number, 35 students.

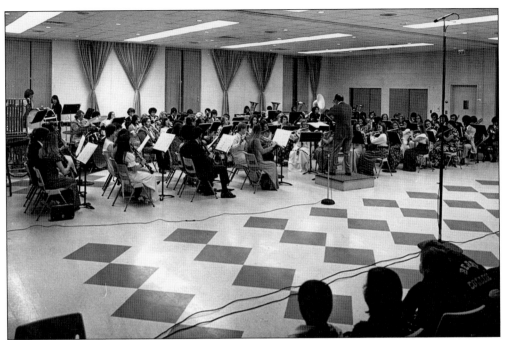

Krannert Center was designed and constructed by the same architect who built Hermann Hall. The building is named for Herman C. and Ellnora Krannert, a prominent family in business. Construction began in 1967, and the building was completed in 1969. For the past 40 years, Krannert has served as the epicenter of campus life and activity, as it houses the current dining hall (since 1978), restaurant, post office, bookstore, meeting spaces, and a ballroom. Above, the symphonic band plays in the new Krannert Ballroom. Under director Jim Clark, the band expanded to its largest size, with over 70 members. Pictured below is one of Berry's largest brass ensembles in 1969. In part, this growth remains attributable to Berry's full accreditation in NASM by 1972.

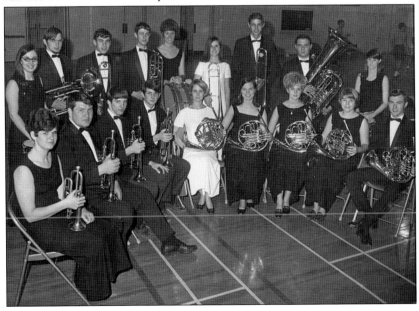

The Jim Clark era began in 1970, and the band grew in size and accomplishment. The group could no longer practice in the smaller Ford Auditorium and many times practiced in Ford Gymnasium instead. From 1967 to 1971, the number of music majors increased 300 percent. The 1970 *Cabin Log* stated, "With the rapid increase in the number of students majoring in music, the entire department is up to its octave in arpeggios." Jim Clark (at left) received his bachelor of music degree from Eastern Kentucky University and his master of music degree from the VanderCook College of Music in Chicago, Illinois. Although he served as the band director until 1979, Clark remained on the teaching faculty until 1985. Clark rehearses the band in 1971 below, and he remains one of the Berry Band's most beloved directors today.

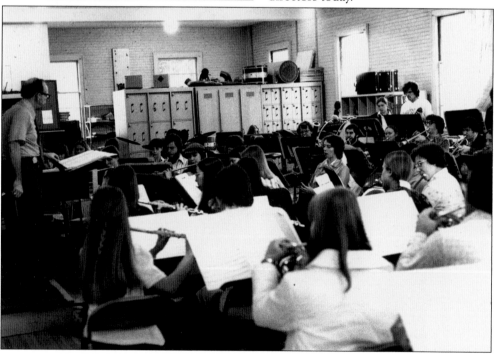

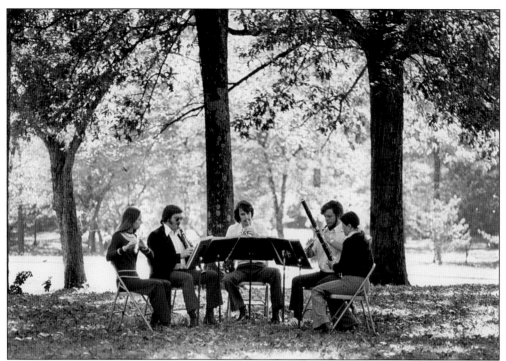

Extending approximately 3 miles from the main campus is Mountain Campus. It serves as the home of some of Berry's best-known landmarks, including Frost Chapel, the Old Mill (which still maintains a working waterwheel), Berry Reservoir, Possum Trot (Martha Berry's first school building), the House of Dreams (built atop Lavender Mountain for Martha Berry's birthday), and Berry's Normandy Dairy, which now functions as a retreat center operated by Chic-fil-A. Other notable features of Mountain Campus include the Gunby Equine Center, biking trails, ropes courses, practice fields, Berry Elementary School (established in 1977), and Camp WinShape (also operated by Chic-fil-A). Above, the Berry Quintet plays amidst the peaceful calm of Mountain Campus in the early 1970s. Below, the 1974 Berry Singers stand on the steps of Oak Hill.

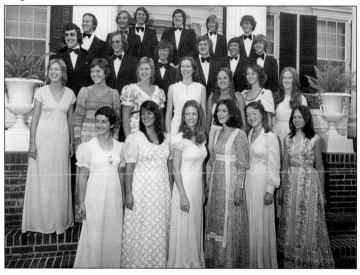

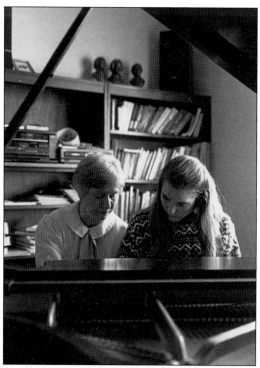

One new hire of the early 1970s was Faye Kesler, who served as the primary piano instructor and an assistant professor of music from 1972 to 2003. Kesler earned her bachelor of arts and master of fine arts degrees from the University of Georgia. Serving for over 30 years, Kesler was a steady force in the music department and a very effective piano teacher (at left).

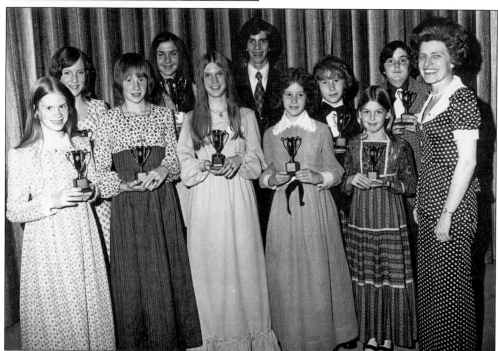

In 1975, Haack-Strong helped lead efforts to bring the National Federation of Music Clubs (NFMC) piano festival to Berry College. This festival hosts piano students from kindergarten to 12th grade, and they are judged on their individual performances. Berry continues to host the NFMC piano festival. Above, Haack-Strong poses with trophy cup recipients.

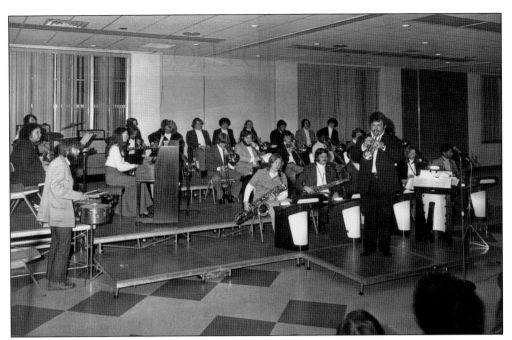

Bill Robison was another new addition to the music department. Robison received his doctor of education degree from the University of Georgia and came to Berry in 1972, the same year that the school earned full membership in NASM. Robison would remain at Berry for 27 years, until his retirement in 1999. He also served as the president of the Georgia Music Educators Association (1974–1975) as well as a board member for many years. As a gifted trumpeter and teacher, Robison transformed the Berry Jazz Band from a sporadically organized group into a music machine.

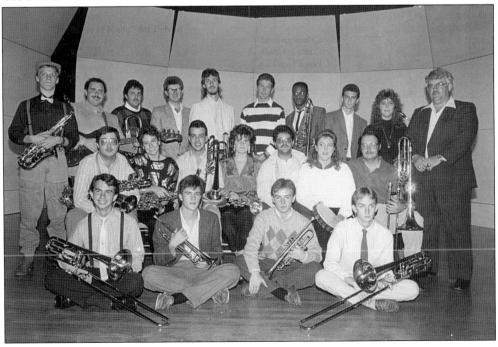

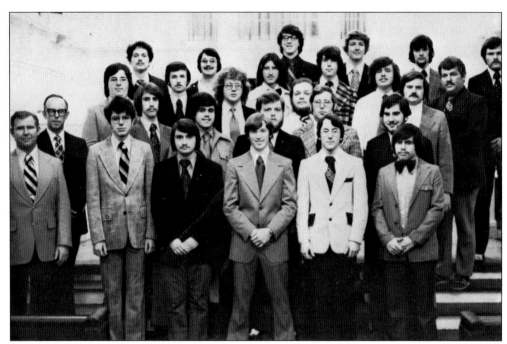

In 1974, Berry College became a new chapter within the Phi Mu Alpha Sinfonia (PMA) music fraternity. This brotherhood of men was established in 1900, when PMA became a national fraternity based in Philadelphia. Today the fraternity includes more than 150,000 initiates and over 200 chapters. Berry's first PMA class is pictured above.

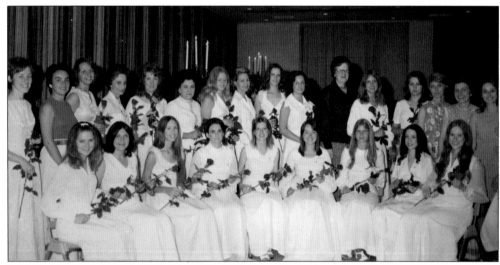

Likewise, 1974 also marked the first year of Berry's membership in Sigma Alpha Iota (SAI) international music fraternity. SAI was founded in 1909 at the University of Michigan School of Music in Ann Arbor, Michigan. This all-female group upholds the mission to encourage, nurture, and support the art of music. Here the charter members of Berry's SAI chapter pose in 1974, including Jo Ann Pethel (far right).

Above, Berry College receives its PMA chapter membership in 1975. Accepting the membership is the school's Dennis Waldrop (second from right), first chapter president, and Bill Robison (far right), faculty sponsor. In addition, Berry College announced its first graduate programs in the early 1970s, offering a master of education and master of business administration in 1972 and 1973, respectively.

The Choral Readers emerged in the mid-1960s and continued through the mid-1970s. The group was traditionally composed of seven men and seven women. They performed in unison, solo, duet, and trio parts from a reading repertoire that included some 50 selections from classic and contemporary literature.

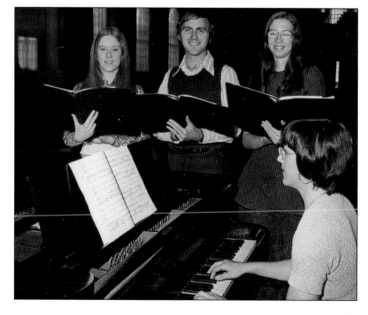

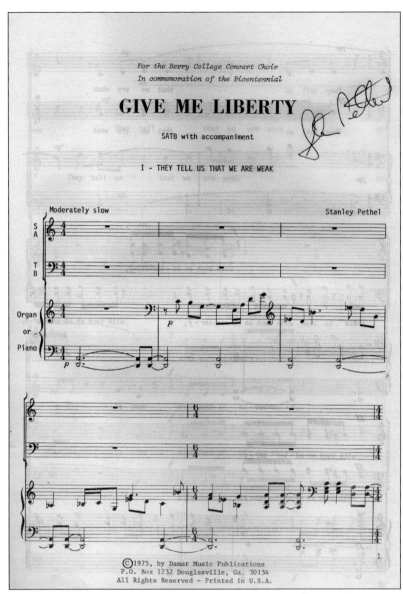

The celebration of the bicentennial of the United States in 1976 proved a momentous year for the Berry music program. Several concerts were organized to celebrate the yearlong affair. One such event involved the brass ensemble, choir, and organ, which all performed *Give Me Liberty*, composed by newcomer Stan Pethel. Accomplished student-musician Susan Giordano played the organ, Magoulas conducted the choir, and Pethel directed the brass ensemble. The performance included additional pieces by the brass ensemble and was produced as an LP record that was later transferred to CD in the 1990s. Hundreds of copies were sold locally and on campus. In an early example of long-distance education, Louise Haack-Strong offered a course in American jazz in 1976 that was broadcast by a local radio station. Students listened to the class in the evenings and came to campus to take exams. A bicentennial concert, held in May, featured the Berry Band. They played *Flag of Stars* by Gordon Jacob, *New England Triptych* by William Shuman, and *Hands Across the Seas* by John Philip Sousa, along with other selected patriotic pieces.

94

Four

VIVACE
1977–2010

The 1970s and 1980s brought a new era of faculty, students, and music to Berry College. New faculty positions were added, which brought fresh faces to campus, including Bill Robison, Faye Kesler, Stan Pethel, and Harry Musselwhite. The United States continued to recover from the Vietnam War and adjust to change brought by social and cultural movements. The nation celebrated its bicentennial and experienced apprehension and relief during months of an economic recession and an international hostage crisis in Iran. By the 1980s, the country had entered "A New Day in America" under Ronald Reagan and regained stability and peace of mind as the cold war drew to a close. As the country endured a "changing of the guards" of sorts, so did music at Berry. The tenures of Ross Magoulas, Louise Haack-Strong, and Jim Clark came to a close in the 1980s. Yet Berry College flourished in the 1990s, and the music department continued to serve as campus stronghold as well as an ambassador for the school. In 1993, Darwin White retired, and Stan Pethel was named the new department chairman.

Seven years later, the nation celebrated a new millennium only to endure the tragedy of September 11, 2001. In 2002, Berry College commemorated its 100th anniversary. Since 1969, after gaining accreditation through the NASM, Berry College has produced many professional musicians. In addition to Michael Hendrick, a professional tenor, other Berry College alumni include Catherine Watson Winter, alto soloist with the Stuttgart Gaechinger Kantorei; Robert Taylor, former bass-baritone with the San Diego Opera; John Howell, former member of New York City Opera; Carrie Anne Eberhardt, soprano with the San Francisco Opera; Daniel Welsh, Air Force Bands trombonist; and Roberto McCausland-Dieppa, piano soloist. Several former students have performed with the Atlanta Opera Chorus or Atlanta Symphony Chorus. Other Berry College music graduates have entered the world of higher education, such as Glenn Eernisse, chair of fine arts at Brewton-Parker College; Mike Brown, chair of music education at Mississippi State University; Jennifer Gundlach, college piano instructor; Joe Searle, Georgia State Department of Education; and Cecily Nall, college professor.

Campus life had certainly changed from the early days at Berry. With uniforms abolished and the cultural trends of the 1970s, students on campus appeared much different than they did before 1960. Long hair, large-pattern prints, polyester, and big glasses dominated the "look" of campus in the late 1970s.

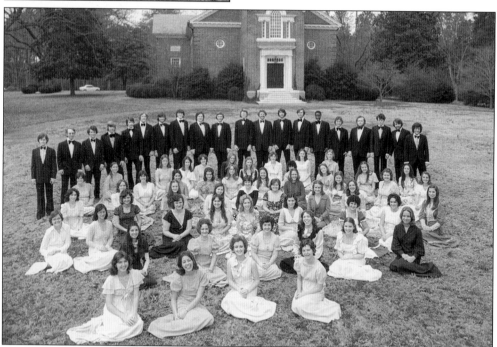

Even formal wear was affected by fashion trends, as evidenced by the 1976–1977 Berry concert choir. The choir stands in front of the Berry College Chapel. The choir continued to recruit large numbers of singers that included majors and non-majors. As one student noted, "Their quantity and quality seems to increase each quarter, and a performance brings out a sizeable audience."

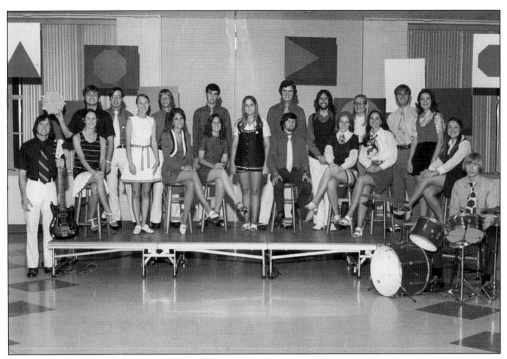

The Ross Magoulas era ended in 1981, and Louise Haack-Strong retired four years later in 1985. These two individuals transformed the Berry College Concert Choir and Berry Singers into premier vocal ensembles with a regional reputation of excellence. Their influence on making music at Berry is apparent from this 1968 report: "Perhaps the most outstanding characteristic of the concert choir is the one which every artistic endeavor must have if it is to succeed, the ability to communicate life. [T]his is possible only through the competence, inspiration, and dynamism of its director, Ross Magoulas, and its accompanist, Louise Haack-Strong." Pictured are the Berry Singers in 1973 (above) and 1977 (below).

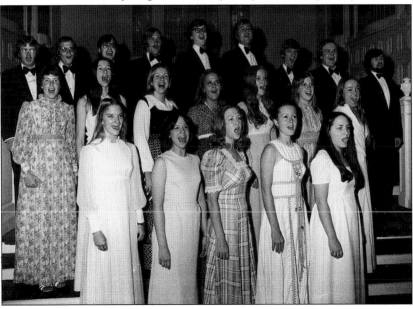

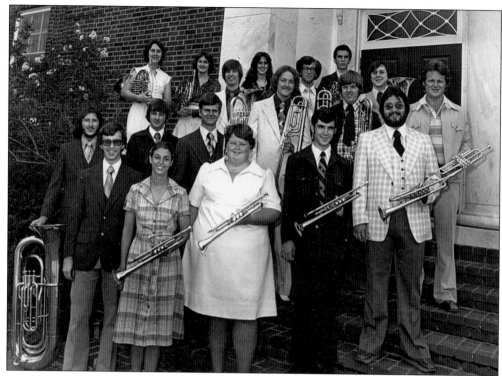

Stan Pethel came to Berry in 1973 at the age of 23 after receiving his master of music degree from the University of Georgia. In 1981, he earned his doctor of musical arts degree from the University of Kentucky. Pethel had an immediate effect on the music program with his organization of a brass ensemble, a trombone group called the Berry Bones, and a trombone quartet. He continues to teach music theory, composition, world music, and individual lessons. Pethel's other talent remains musical composition, with over 1,300 published works by 2010. He has composed and arranged for band, orchestra, choir, piano, and organ in nearly every musical genre. Above, the brass ensemble takes a picture in 1976 with Dr. Pethel (front left). Below, Pethel (second from right) blends in with the Berry Bones as the group strikes a creative pose in 1978.

Students majoring in music at Berry College maintained a very demanding schedule. The *Cabin Log* reported that "No one ever sees a music major until at least 11 p.m., and then he's probably reciting Gregorian chants or waving his arms in 4/4 time." Despite the witty commentary, music majors spent hours beyond class time practicing, studying music theory, participating in ensemble(s), and preparing for student recitals. Most music majors also joined Phi Mu Alpha or Sigma Alpha Iota, which offered camaraderie as well as opportunities for service. Pictured at right is a promotional brochure, and below, the French horn section is captured in a 1979 performance.

MUSIC AT BERRY COLLEGE
MOUNT BERRY, GEORGIA

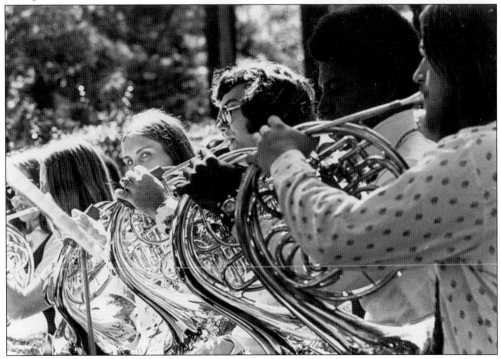

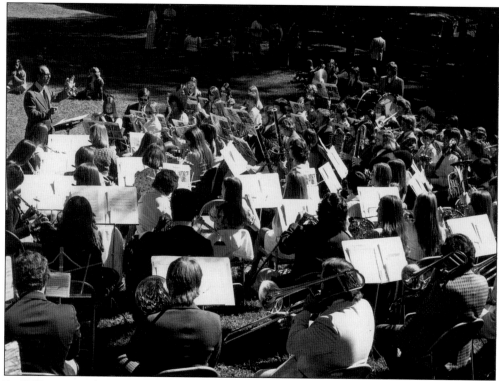

In 1980, one student commented, "Music majors don't really have their heads in the clouds. They simply have their minds on planning for tour, giving a senior recital, presenting concerts, digesting music theory, laughing at Mr. Magoulas's jokes, and learning to live like a family." After gaining full membership in NASM in 1972, music majors were required to participate in either the band or the concert choir for each enrolled quarter. Music education major Linda Fitzgerald stated in 1979, "Music Majors are close—like family. There is a lot of hard work involved, but that means you're learning something." Above, Jim Clark directs the symphonic band on Mountain Day in the late 1970s. Below, female students play bassoon during practice in 1980.

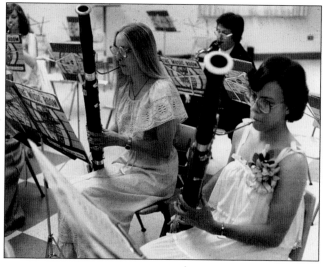

The keyboard program had long established a reputation of excellence, and students studied piano, harpsichord, and organ. Here Faye Kesler teaches a class in 1981 in a renovated music lab equipped with new electric pianos. In the early 1980s, electric pianos were extremely popular due to their mobility and variety of keyboard sounds. Kesler also served as a longtime faculty sponsor of the Sigma Alpha Iota women's music fraternity.

Beginning in the early 1980s, music ensembles began touring local elementary schools giving musical demonstrations and abbreviated concerts. Nearly three decades later, the brass quintet continues this tradition, sharing the joy of music with potential young musicians each year. At right, the jazz band watches as Berry brass player Lane Anderson (right) and Terri Hinton (left) entertain and educate an elementary audience.

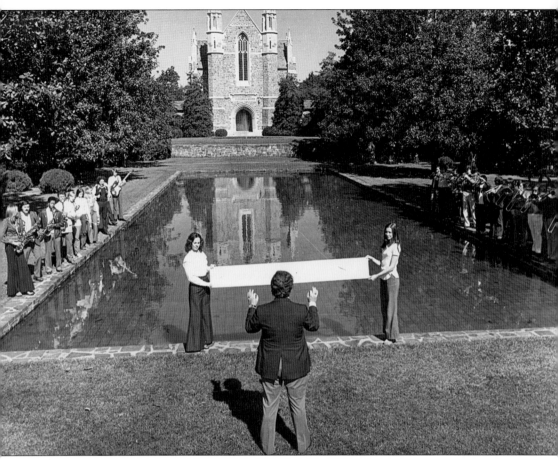

For over a decade, the music department lacked space and a collective home. By 1975, the dilemma was apparent to students and faculty alike. According to the *Campus Carrier*, "There are actually no facilities at Berry specifically for music. . . . The space available is not adequate; neither is it comfortable." During 1978, a number of the front buildings in the Ford complex were renovated, and in the fall of 1979, the Berry music department moved into its new domicile. Today the department continues to reside in the Ford Buildings and contains a 400-seat recital hall, ensemble rehearsal facilities, recording studio, computer lab, music library, classrooms, practice rooms, and faculty offices. Above, Bill Robison directs the jazz band around the Ford reflection pool in 1980.

Charlotte Smith-Cook taught at Berry from 1974 through 1982 as an instructor in double reed instruments and music history. She received her bachelor of music degree from Furman University and her master in music degree at the University of North Carolina, Chapel Hill. She also established the Berry Flute Ensemble, which still performs on campus and in the greater Rome area.

Although Berry had not regularly produced a male quartet since the 1950s, a new barbershop quartet became all the rage in the late 1970s. From left to right, Craig Harbin, Chris Bouchard, Andy Fowler, and Sandy Hosea sang to enthusiastic crowds from 1978 to 1980. Above, they sing in barbershop costume in 1979.

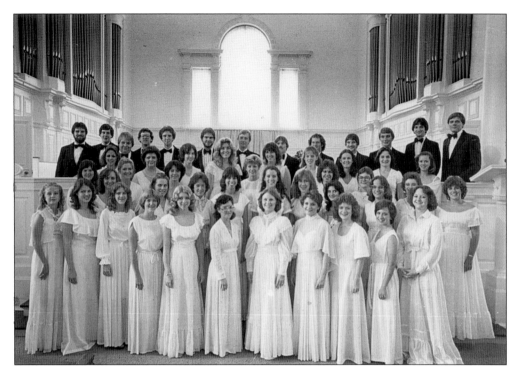

The boys' high school, renamed Berry Academy in the 1960s, continued to provide secondary education, as the Berry Schools became Berry College. In 1983, the Berry Academy closed its doors. Many current and former students fought the academy's closing, but regardless of their efforts, the high school division came to an end. Prior to 1936, this secondary program provided the largest enrollment numbers for the Berry Schools; however, student numbers had declined in the 1960s and 1970s. As one Berry chapter closed, another began with the addition of the education specialist degree in 1985. In addition, Berry College was listed in the *New York Times* and *U.S. News and World Report* as a top liberal arts college. The music department continued to contribute to the college's strong reputation. The 1981–1982 Berry College Concert Choir (above) is pictured in the chapel, while the Berry Bones (below) enjoy time together after a rehearsal in 1986. Drummer Wade Williams (center) currently teaches percussion at the college.

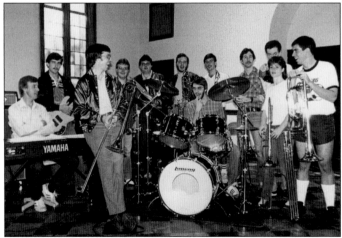

In 1985, Harry Musselwhite became the new face of the choral program. Musselwhite received his bachelor's degree from the University of Georgia and master of music degree at the University of Indiana. He also possesses a distinguished vocalist career performing with the Chattanooga Opera, Santa Fe Opera, New York Russian Choral Festival, and the Virtuosi of London, to name a few. Musselwhite quickly gained a reputation as a passionate director with a magnetic personality.

Several members depicted a typical 1980s concert choir rehearsal: "During the middle of an intense practice while going over [a] line of the German opera piece for the eighteenth time, Mr. Musselwhite interrupts . . . and bursts into a David Letterman–like dialogue that leaves the choir [both] laughing and relieved. . . . It took serious work to learn operas in five languages . . . it took a little fun too." One of Musselwhite's first productions was a musical entitled *Down in the Valley* (above).

Down in the Valley was the operatic debut of Michael Hendrick, who went on to perform at the Metropolitan Opera and New York City Opera, among others. In the 1990s and early 2000s, the Berry Singers also presented *H.M.S. Pinafore* and *Trial By Jury*, by Gilbert and Sullivan. Hendrick (above), who also played trumpet at Berry (1983–1987), continues as a professional tenor.

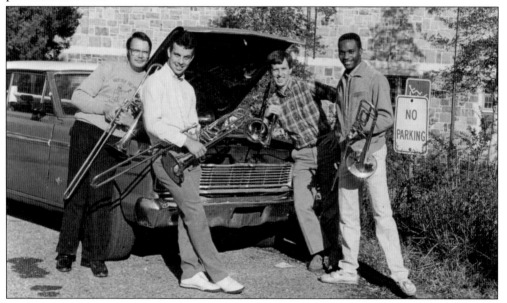

Berry College formed a trombone quartet for several years in the late 1980s and early 1990s. The group played at many local events including festivals, churches, and special concerts. The 1989 quartet included, from left to right, Chris Miller, Gene Greer, Stan Pethel, and Dewaine Johnson.

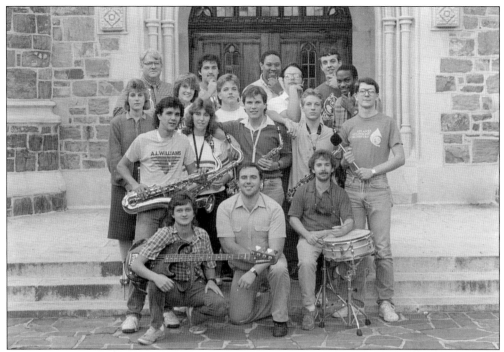

The Berry Bones and jazz band averaged 20 performances a year in the 1980s. Both groups were composed of music majors and a sprinkling of non-music majors. In addition to ensemble practices and performances, the average music load carried 18 hours of courses and lessons per semester. Participating in groups such as the jazz band or Berry Bones also counted for an hour of coursework. Paul Thurmond, class of 1987, commented, "The only thing that kept me going was my love for music." The jazz ensemble (above) poses with director Bill Robison (top left) in 1987, while the Berry Bones (below) showcase their talents for an audience and a local news program.

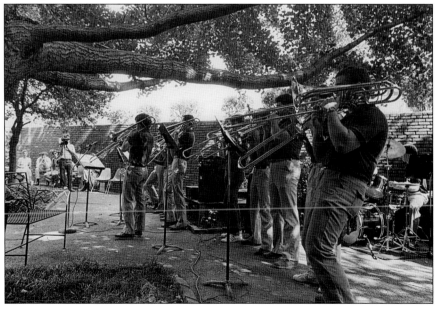

The choir tour of 1987–1988 was a memorable one, with performances both in Washington, D.C., and in the New York City area. Director Harry Musselwhite remembers the tour fondly. "We took a huge choir on two large touring buses and performed a varied concert, always ending with great American spirituals." In addition to annual choir tours, selected Berry choir members served as the choral group chosen to sing with the Chattanooga Symphony. For several years, this collaborative musical effort brought professional opportunity for Berry vocalists. Memorable performances included Mahler's Second Symphony and Beethoven's Ninth Symphony. The group also worked with conductors Vaktang Jordania and Robert Bernhardt. Above, the Berry College Concert Choir poses with congressman Buddy Darden on the steps of the U.S. Capitol during its 1987–1988 tour.

Berry's largest instrumental group remained the band; however, in the late 1970s, the ensemble officially became the Berry College Symphonic Band. In part, the name change reflected the fact that the school no longer maintained any kind of marching band. Department chairman Darwin White (at right) directs the symphonic band at the Mountain Day celebration in 1985. While his focus remains centered on directing, White's granddaughter also seeks his attention. The jazz band maintained widespread popularity, and several faculty members often played with the group. Below, Darwin White (seated left) plays saxophone alongside the ensemble's director, Bill Robison, on trumpet (standing right) in Ford Auditorium. Several smaller groups formed in the 1980s, including a stage band, a pep band, and brass ensembles, proving that "Berry's various bands provide the stage for the presentation of the outstanding abilities of the many music majors (*Cabin Log*)."

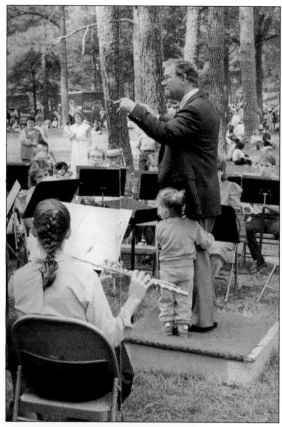

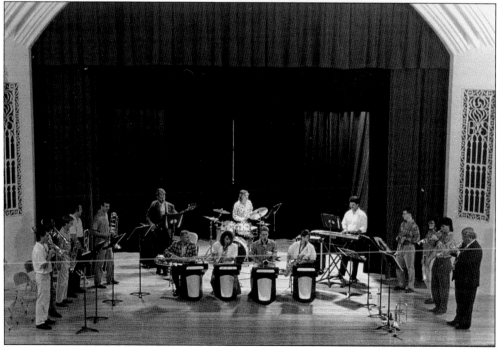

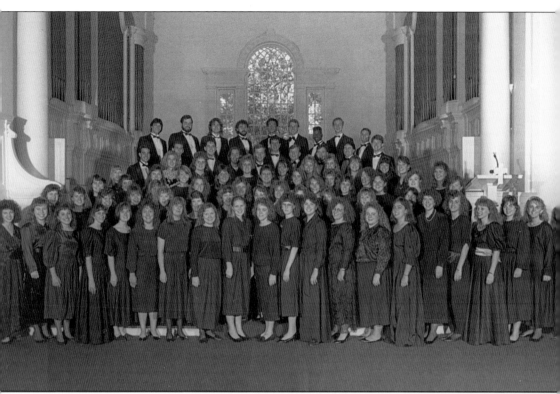

As Berry moved into the last decade of the 20th century, the school replaced the quarter system with the semester system. Most colleges and universities in Georgia also made the switch in the 1990s. Meanwhile the music department remained content in its new home, the Ford Buildings. Although separated from the majority of main campus classroom buildings, music majors enjoyed the freedom to practice and rehearse. The *Cabin Log* cleverly reported that, "[w]ay up at Ford, tucked away in their various classrooms, the music students sing, pound, blow, pluck, and conduct their hearts away." Above, the 1989 Berry College Concert Choir stands in the chapel. The group enjoyed substantially larger numbers in the late 1980s.

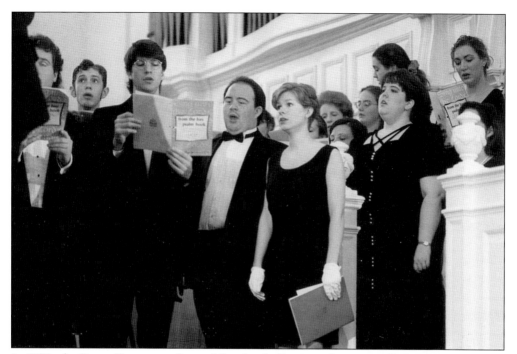

In 1991, the Berry Singers performed for the dedication of Evans Hall, formerly known as Trustees Hall. In the same year, the Berry Chapel Choir combined with the theater department to produce Berry's first musical in five years, *To Whom it May Concern*, which addressed issues of faith with a twist of humor. Above, the 1995 Berry Singers perform from the Bay Psalm Book, first published in 1640.

In 1992, Martha Berry was inducted into the Georgia Women of Achievement Hall of Fame. Coincidentally, Berry College celebrated its 90th anniversary. In honor of the event, Stan Pethel arranged the school hymn, "Our Hope for Years to Come." At right, this piece rests on the chapel piano before one of the celebratory events.

Ruth Baker continues as a lecturer of music. She has been a part of the Berry music family since 1989. Baker earned her bachelor of music and master of music degrees from the University of Georgia and teaches voice, music appreciation, music education, and music history at Berry. Above, Baker gives a voice lesson to student Ellie Johnston in 2009.

In the 1960s, a group of music educators in Germany collaborated to create Kindermusik, a program for children to experience the joy of music prior to instruction in a formal setting. In 1989, Berry music alumna Kathryn Nobles (at left) started Kindermusik with nine children from Berry's Child Development Center. Currently over 150 children are enrolled in weekly classes for newborns to age seven. Berry students assist with classes, and several graduates have established programs in various cities throughout the southeast. The motto for Kindermusik is "a good beginning never ends."

The department promoted its music program in the early 1990s with a campaign motto of "Higher Aspirations." The program overview proclaimed that "[t]he study of music at Berry transcends music education. It represents that truly preferred but seldom attained experience—music and an education." In addition, music students could earn scholarships from $1,000 to full tuition through the Keown, Dorminy, and Hoogewerff scholarship programs. The 1990s also served as a decade of major fund-raising through the efforts of Berry's president, Gloria Shatto. Appointed in 1980, Shatto was the first female president of Berry and the sixth overall. In her 18-year tenure, Shatto engineered major efforts to secure endowment funds and further the school's growth. Shatto passed away in 2008, but her words ring true: "Berry is many things—beautiful campus, fine facilities, excellent programs but most important, Berry is people." Above, Shatto accepts the money collected by students for Mountain Day.

Berry has maintained a woodwind ensemble for nearly 20 years. The 1992 woodwind ensemble included, from left to right, Amy White, Keith Collins, Mark Bankston, Dr. Henry Grabb (director), and Kory Vrieze. Grabb served as a double reed instructor in 1991 and 1992. His recommendation for a new woodwind instructor stayed in the family, and Berry hired his sister, Peggy Moon. Moon taught at Berry College from 1993 to 1996.

John Davis (left) arrived in 1996 to assume directorship of the band after Sam Baltzer, who led the band from 1994 to 1996. Davis received his doctor of musical arts degree at the University of Arizona. Davis served as the band director until 2008 and continues on the faculty. Above, Davis stands with the 2001 flute choir.

Weill Recital Hall
at
Carnegie Hall

Berry College
Chamber Choir

Harry Musselwhite
Director

Performing
Handel, Schubert, Mendelssohn, Thompson, Copland

June 1, 1998
8:00 p.m.

VF980908-8

The Berry College Chamber Choir performed a solo concert at Weill Recital Hall at Carnegie Hall in honor of the new presidency of Dr. Scott Colley. On the same tour, the choir sang in the rotunda of the U.S. Senate building in Washington, D.C. Kenneth Moyers was the accompanist for both concerts, which featured selections from Schubert's Mass in G. In addition to tours in the United States, special chamber groups have performed in historic cathedrals throughout Europe, including Wells Cathedral in the United Kingdom, Sacre Coeur in Paris, Sint Agatha Kerk in Amsterdam, the Basilica of the Apostles in Cologne, Kzesky Krumlov in the Czech Republic, and St. Margaret's in London. Harry Musselwhite describes making music in these important musical centers as an "honor and a thrill." Musselwhite also remarked, "Our performance at the Kulturzentrum in Salzburg was wonderful. It was an especially memorable moment as we combined with a folk choir for a performance of a Mozart motet in his hometown under my direction."

Scott Colley was named Berry's seventh president and served from 1998 to 2006. Colley continued Martha Berry's legacy of academic excellence. Colley also took a personal interest in the music department because of his previous studies in trombone. He was an honorary member of the Berry brass ensemble, attending required rehearsals along with undergraduate students. Colley (left of center, back row) also performed with the group.

The Berry Schools maintained separate glee clubs for males and females until the 1950s. Ironically, in 1998, a men's ensemble emerged, unknowingly reviving a Berry College tradition. Here the 2000 Berry College Men's Ensemble poses for a photograph. Members include, from left to right, Kevin Baugh, Kirk Powell, Kevin MacHarg, Kevein Mulligan, Matthew Williams, John Faye, Michael Smith, Chris Barry, and Brandon Seay.

Lift Up My Eyes — *Stan Pethel*
...med by the Concert Choir. Harry
...white, director

...ren We Have Met to Worship —
...onal. arr. Stan Pethel. Published by
...Press. Brass Ensemble

...resque — *Segei Rachmaninoff*
...med by Katie Hughes, piano

...ure to Candide — *Leonard*
...tein Published by *Bourne*.
...onic Band, John Davis, director

...any Boy.* — *Irish Folk Song. arr.*
...ouson. Published by *Neil A. Kjos, Jr.*
...'s Ensemble, Ruth Baker, director

10. **A Mazy Motion** — *Tim Huesgen*
Published by *Meredith Music*. Dedra
Groover, vibraphone.

11. **The Church's One Foundation** —
Tradition. arr. Published by *Light of the World Music*. Stan Pethel

12. **Passacaille*** — *A. Barthe*. Berry
Woodwind Quintet. Tama Kott, director

13. **Macumba** — *Victor Lopez*. Published by
Warner Bros. Berry Jazz Ensemble, Tom
Smith, director

14. **My Romance** — *Rodgers and Hart*.
Applescraps, Faculty combo

music 2003
I Will Lift Up My Eyes

...p. 8 #4 — *Augustin Barros*
...ré John Martin, guitar

...rto in G for Flute* — *W.A. Mozart*.
...College Orchestra, Susan Davis.
...John Davis, director.

...na Variations — *Edward Elgar. arr.*
...Davis. Published by *Falls House*
...Berry College Flute Choir, John
...director

...pts from Symphony No. 9* —
...g von Beethoven. Concert Choir
...ome Symphony Orchestra

Produced by Dr. Stan Pethel,
Chair of Fine Arts, Berry College.

Berry Music Web Site
www.berry.edu/music
Phone - 706-236-2289

Design & Photography
Matt Ankerich, Creative Matter
www.homepage.mac.com/mattankerich

The production of this compact disk was
made possible by a generous gift from
Earl Tillman.

I Will Lift Up My Eye

Berry College
music 200...

The first sampler CD was recorded in 1999 and includes performances by ensembles, students, and faculty. It serves to represent works done throughout the year. From 2005 to the present, a sampler has been produced annually. Examples of pieces performed on past sampler CDs include *The Peaceable Kingdom* by Randall Thompson, W. A. Mozart's Symphony No. 34 for Orchestra, *Excerpts from Elijah* by Felix Mendelssohn, Brass Quintet by Malcolm Arnold, William Schumann's *Chester Overture for Band*, and *Just Friends* (jazz ensemble) arranged by David Wolpe. The 2003 CD includes the 2002 anthem written by Stan Pethel for the Berry College centennial entitled "I Will Lift Up My Eyes."

The Oak Hill Orchestra began in 2002 as a joint collaboration of Berry students and members of the Rome Symphony Orchestra. Northwest Georgia has long been known for its cultural and musical arts outside of the Atlanta area, and the Oak Hill Orchestra only strengthens its reputation. Former Berry Band director John Davis first conducted the orchestra. Currently Norman Bernal (above) directs the group. Mirna Ciric, a violin instructor at Berry, serves as associate conductor. The Oak Hill Orchestra was named for the Berry family's estate, which is adjacent to the main campus and maintains the family home and the Martha Berry Museum. The grounds of Oak Hill also include the famous log cabin where Martha Berry first taught rural children in the late 1880s.

In the early 1990s, a clarinet choir was formed by Wanda Dugger, who served as departmental secretary and clarinet instructor. Pictured at right is one of the first groups formed. The 2001 clarinet choir members include, from left to right, (first row) Suzanne Storey, Candice Micromatis, and Kim Cooper; (second row) Jennifer Schroeder, JoAnn Blaylock, and Wanda Dugger.

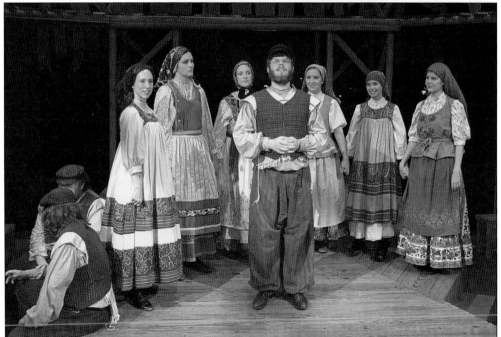

Fiddler on the Roof (2004) and *Annie Get Your Gun* were musicals done in coordination with the Berry College Theatre Department, and *Oklahoma* (2007) was a Berry Concert Choir production. *Fiddler on the Roof* has music by Jerry Bock and lyrics by Sheldon Harnick. The plot is set in Tsarist Russia in 1905, and the original story is based on *Tevye and his Daughters* by Sholem Aleichem.

The Berry Symphonic Band continued to make masterful music in a new century. The band toured throughout the region in 2006, impressing audiences both on and off campus. Above, John Davis directs the fall semester concert held in Ford Auditorium.

Tom Smith taught music education and high brass from 2002 to 2007. Smith received his master of music education degree from Florida State University and his doctorate from the University of Texas. In addition to his teaching duties, Smith led the jazz ensemble after the retirement of Bill Robison. Above, Smith solos in a concert of *Cantata for Peace* by Daniel Moe, which featured the choir, organ, and trumpet.

The music computer lab opened in 2001 for the purpose of music composition and arranging, as well as general research. Four years earlier, the music department established a recording studio. In 2009, the studio switched to digital recording with new software programming. Beginning in 2010, the music department offered a new course for credit, Introduction to Digital Recording.

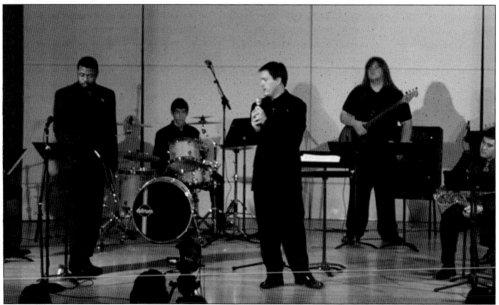

Adam Hayes was appointed to the music faculty in 2008. He directs the Berry jazz ensemble and teaches music theory, appreciation, and trumpet. He received his master of music degree from the University of New Mexico. Above, Hayes (right) appears with guest trumpet soloist Melvin Jones (left) in 2008.

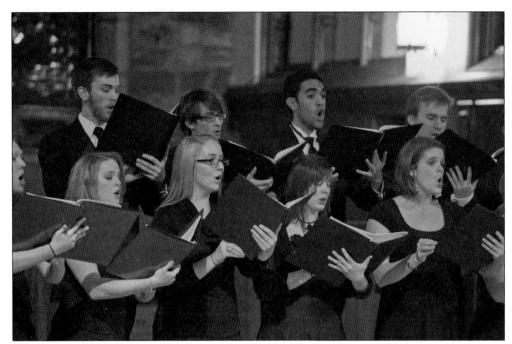

Frost Chapel remains a treasured venue and sacred space at Berry College. In 2008, the Berry Singers held their fall concert in Frost Chapel, blending harmonious song with the acoustics of stone and stained glass.

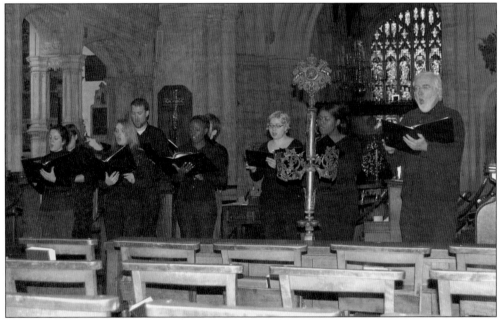

Berry's music department organized a special chamber choir for its 2008 British tour. The choir traveled throughout Great Britain for 10 days, singing for various events and performing in several venues. Led by director Harry Musselwhite (right), the trip culminated with a performance in William Shakespeare's church. The church is formally known as the Collegiate Church of the Holy Trinity of Stratford-upon-Avon.

BERRY COLLEGE

Fine Arts Department
Fall 2007 Events

"Renegades" Art Exhibit
Aug. 27-Sept. 21
Moon Gallery**

"Back to Berry" Alumni Show
Sept. 24-Oct. 19
Moon Gallery**

Community Choral Celebration (Concert Choir)
Sept. 30, 4 p.m.
Darlington School

Michell Tabor, piano/Alphonso Lopez, violin
Guest Recital
Oct. 1, 8 p.m.
Ford Auditorium

A Funny Thing Happened on the
Way to the Forum (PG-13)
Oct. 4-7 and 9-11, 8 p.m.
E.H. Young Theatre*

Early 20th Modernism in Art, Architecture
and Design (Lecture by Virginia Troy)
Oct. 18, 7 p.m.
Oak Hill

"Treasures of Rome" Art Exhibit
Oct. 22-Nov. 16
Moon Gallery**

Faculty Recital
John Davis, flute/Kris Carlisle, piano
Nov. 7, 8 p.m.
Ford Auditorium

The Stick Wife (PG-13)
Nov. 8-11, 8 p.m.
E.H. Young Theatre*

Fall Choral Festival (Berry Singers)
Nov. 11, 3 p.m.
College Chapel

Symphonic Band
Nov. 14, 8 p.m.
Ford Auditorium

The Stick Wife (PG-13)
Nov. 15-18, 8 p.m.
E.H. Young Theatre*

Jazz Ensemble
Nov. 15, 8 p.m.
Ford Auditorium

Opera's Greatest Hits (Concert Choir)
Nov. 18, 3 p.m.
College Chapel

Senior Thesis Art Show
Nov. 19-Dec. 14
Moon Gallery**

Oak Hill Symphony Orchestra
Nov. 27, 8 p.m.
Ford Auditorium

Lessons and Carols
Dec. 4, 7 p.m.
College Chapel

Woodwind Concert
Dec. 6, 8 p.m.
Ford Auditorium

*8 p.m. Thursday - Saturday/ 2 p.m. Sunday
**Gallery Hours: M-F 9 a.m. - 4 p.m. and by appointment

The art, music, and theater departments were combined into the fine arts department in 2001 with one chair instead of three. Dr. Stan Pethel was named the chair of fine arts. The fine arts program is a major part of the cultural events program at Berry. According to the *Viking Code*, "The [Cultural Events] program is designed to expose students to events that faculty and administration believe best represent the literary, philosophical, and performing arts traditions for which Berry as an institution is responsible; . . . and to enable students to participate as fully as possible in the intellectual and spiritual tradition of Berry College. Typical credited events include concerts, plays, lectures, debates . . . [and] convocations." As such, these students are required to attend a total of 24 cultural events before graduation. This program reemphasizes the musical foundation at Berry and highlights the crucial role of music in education.

Glenn Garrido has served as band director since 2008, and the group has been renamed the Berry Wind Ensemble. Garrido received his master of music degree at the University of New Hampshire and his doctorate of philosophy from the University of Florida. He teaches music education and supervises student teachers. In two years, under Garrido's leadership, the group has grown from 55 to 70 members.

Beginning with one music teacher in 1906, Berry College now boasts a music faculty with more than 12 full-time and adjunct positions. The 2010 faculty includes, from left to right, (first row) Stan Pethel, chair of fine arts and low brass; Kay Simms, administrative assistant; Ruth Baker, voice; and Kathryn Nobles, piano; (second row) Harry Musselwhite, voice; Mickey Fisher, woodwinds; Wade Williams, percussion; Glenn Garrido, woodwinds; Adam Hayes, trumpet; Kris Carlisle, piano; and John Davis, woodwinds.

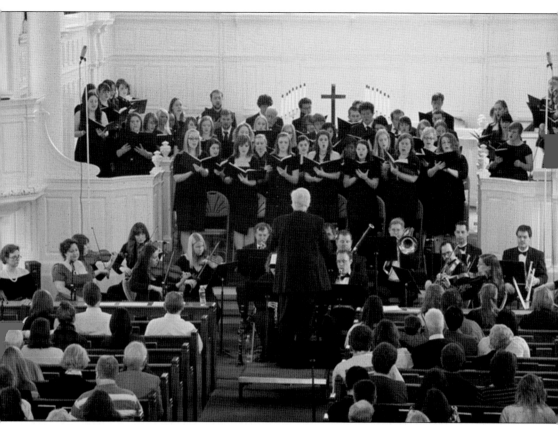

In 2009, the Berry College Concert Choir, accompanied by an orchestra, performed Mozart's Requiem with Harry Musselwhite directing (above). Playing to a full audience in the main chapel, this collaborative concert lends the perfect opportunity for reflection. Martha Berry, laid to rest just outside the chapel, surely would have been filled with pride. Music at Berry was an emphasis for the school's founder, but the growth and development of the music program has sustained Berry's standard of excellence for a century. Berry College has given budding musicians the opportunity to meld endeavor with talent, turn melody to harmony, and to perform on life's many stages—all the while making music.

BIBLIOGRAPHY

Ballad Girls; Faculty/Staff; Music Department; Band; Choir; Mountain Day. Photograph Collection. Berry College Archives. Memorial Library.

Berry Alumni Quarterly. Mount Berry, GA: Berry College, 1914–1975.

Berry College Catalog. Mount Berry, GA: Berry College, 1959–1980.

Berry Schools Bulletin. Mount Berry, GA: Berry College, 1909–1958; 1967–2009.

Cabin Log. Mount Berry, GA: Berry College, 1935–2009.

Campus Carrier. Mount Berry, GA: Berry College, 1963–1990.

Interview with Ouida Word Dickey, Harry Musselwhite, and Darwin White, 2009.

Mathis, Doyle, and Ouida W. Dickey. *Martha Berry: Sketches of Her Schools and College.* Atlanta: Wings Publishers, 2001.

Mount Berry News. Mount Berry, GA: Berry College, 1958–1963.

Record Group 28—Berry College Department of Music. Berry College Archives. Memorial Library.

Shatto, Gloria. "Moving Vigorously Into the Future." Speech delivered to Newcomen Society of the United States, 1984.

Silver and Blue. Mount Berry, GA: Berry College, 1928–1932.

The Southern Highlander. Mount Berry, GA: Berry College, 1906–1966.

The Spectrum. Mount Berry, GA: Berry College, 1918.

INDEX

www.arcadiapublishing.com

Discover books about the town where you grew up, the cities where your friends and families live, the town where your parents met, or even that retirement spot you've been dreaming about. Our Web site provides history lovers with exclusive deals, advanced notification about new titles, e-mail alerts of author events, and much more.

MADE IN THE USA

Arcadia Publishing, the leading local history publisher in the United States, is committed to making history accessible and meaningful through publishing books that celebrate and preserve the heritage of America's people and places. Consistent with our mission to preserve history on a local level, this book was printed in South Carolina on American-made paper and manufactured entirely in the United States.

This book carries the accredited Forest Stewardship Council (FSC) label and is printed on 100 percent FSC-certified paper. Products carrying the FSC label are independently certified to assure consumers that they come from forests that are managed to meet the social, economic, and ecological needs of present and future generations.

FSC
Mixed Sources
Product group from well-managed forests and other controlled sources

Cert no. SW-COC-001530
www.fsc.org
© 1996 Forest Stewardship Council

Find Your Place in History.